TECHNIQUES OF FANTASY ART

TECHNIQUES OF
FANTASY
ART

BRUCE ROBERTSON

Macdonald Orbis

Foreword

There is strength through mystery. A picture produced from the images within the mind can be a more accurate portrayal of human perceptions than one based entirely on observations. When we look at the work of a fantasy artist we can respond to the mystery on a number of levels: the source of the ideas, the constituent parts, and the subject matter of the picture. The construction of the composition, its use of the elements of light and shade, and its depictions of imaginary forms are all crucial. Finally comes our response to the mysteries of the artist's technique – his painting skills.

The creation of fantasy art is achieved by the interplay of the conscious and the unconscious mind. This process was described in 1540 by Leonardo da Vinci, the Italian Renaissance master, as a challenge to the artist who must resolve a conflict between the observed and the imaginary, the known and the unknown.

Images of the imagination appear in all forms of art, for example: the decorative and applied arts, sculpture and, surprisingly, architecture. This book excludes all the forms mentioned above and concentrates instead on images, either painted or drawn, on two-dimensional surfaces. It uses examples by commercial artists, those working on commissions, or artists exploring their own visual references and imagination. The vast resource of images made by people suffering from mental disorders who, as a result of illness or congenital deficiencies, create images directly from the disturbance of their minds is not included.

The greatest source of imaginary images is literature, both prose and poetry. The flow of words creates worlds which we mentally visualize. Stories from legends, mythology, gothic horror stories, science fiction and fiction itself create images of new worlds in our minds. The depiction of these 'imaginings' makes a direct appeal to us through recognition of the element of common experience in life. Since fantasy art is not totally dependent upon observable reality, we are likely to be

A Macdonald Orbis BOOK

© Diagram Visual Information Ltd 1988

First published in Great Britain in 1988 by Macdonald and Co (Publishers) Ltd London and Sydney

A Pergamon Press plc company

British Library Cataloguing in Publication Data

Robertson, Bruce
Techniques of fantasy art
1. Drawings
I. Title
741.2 NC730
ISBN 0-356-15324-X

The Diagram Group

Editorial staff
Ben Barkow, Guy Brain, Annabel Else, Moira Johnston, Patricia Robertson

Indexer
David Harding

Art director
Philip Patenall

Artists
Joe Bonello, Alastair Burnside, Robert Chapman, Richard Hummerstone, Mark Jamill, Lee Lawrence, Paul McCauley, Katherine Mothersdale, David O'Brien, Guy Ryman, Jane Robertson, Michael Robertson, Graham Rosewarne

Picture researcher
Patricia Robertson

Typeset by Dorchester Typesetting Group Ltd
Printed and bound by Purnell Book Production Ltd

Macdonald and Co (Publishers) Ltd
Greater London House
Hampstead Road
London
NW1 7QX

disturbed by our examination of the works of fantasy artists. They surprise us by their inventions which, once we have seen them, live in our minds as ghosts of the unreal world.

Today the work of a good fantasy artist is in constant demand by the commercial world. Examples are everywhere: video cassette covers, record sleeves, science fiction novels, movie posters, and advertisements. The commercial artist produces work which is often derived from the discoveries of 'fine artists.' Nowadays commercial art can become 'gallery' art and is in turn reinterpreted – the copier is copied. Even the most commonplace image torn from a magazine can be the source from which unique pictures are created. Remember when setting out on the path of producing fantasy images that you may be more surprised with your discoveries than subsequent viewers of your work. However, each new picture is a new contribution to the vast world of the imagination of mankind.

- Section One of the book looks at the source of ideas. Where do artists get their inspiration for imaginary pictures?
- Section Two explains the background to eight famous fantasy paintings: the artist's motivation, the origin of the illustrated ideas, and the potential audience. This section takes an example from a selection of famous artists' work and, although depicting the examples in full color, concentrates on the ideas behind the pictures rather than the techniques used to produce them.
- Section Three explores methods of developing ideas and shows how they may be distorted or enlarged in scope by the use of collage or changes in composition.
- Section Four concentrates on the physical processes required to produce a fantasy image in a variety of media, and contains interviews with eight contemporary artists. The artists explain their techniques and discuss the development of an idea into a finished product.

Acknowledgements
A personal thank you to each of the eight artists whose work appears between pages 96 and 126. Without their help in patiently explaining their techniques I could not have produced those pages. Thanks are also due to my old Professor of Art, Edward Wright, who kindly read the book and offered very constructive advice about the ideas contained in it, many of which I had remembered from his lectures.

Contents

Section Three
DEVELOPING IDEAS

Section Four
TECHNIQUES AND TIPS

GREAT
RACKETING
ROCKETS !

Section One
Generating ideas

Fantasy art comes from your imagination, and has its origins in your immediate surroundings and the past experiences of your life. You should begin with the familiar and develop your ideas to more imaginative levels. Each new discovery will increase your abilities to explore further the sources of your imagination. The end result may be far in excess of what you first thought you were capable.

Section One begins by describing some of the most conventient ways of stirring your mind so that it yields images for your paintings. Where do ideas and images come from? Our cultural origins greatly influence the sources of inspiration. Can reality be used to transform images into our fantasy world? Perhaps examining a piece of old wood or cut-up cabbage, or an unfamiliar tool, can begin the chain reaction. Discovering unknown worlds in specialized books and magazines can open the door to a new fantasy picture. Photographs, either your own, or those taken from a variety of other sources, can be incorporated into your pictures.

Finally the greatest source of ideas may be the work of other fantasy artists. Never reject plagiarism – it is the soil from which flowers grow. The great 17th century scientist Isaac Newton, when asked in his old age how he had made so many wonderful discoveries, replied: "Because I stood on the shoulders of giants." By using his enormous library as the starting point for much research, Newton had benefited from the previous work of other great scientists.

Henry Koerner's painting *Mirror of Life* portrays a number of events in the artist's life.

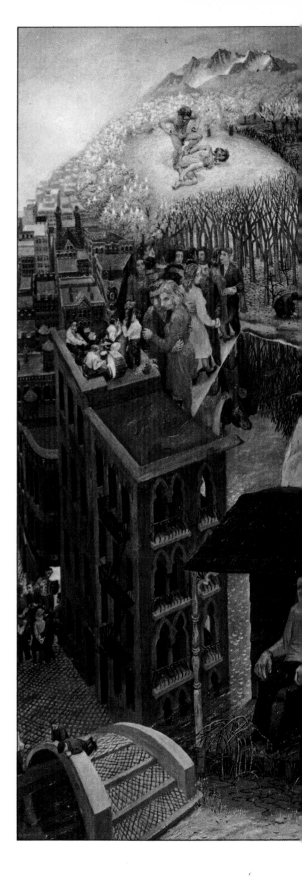

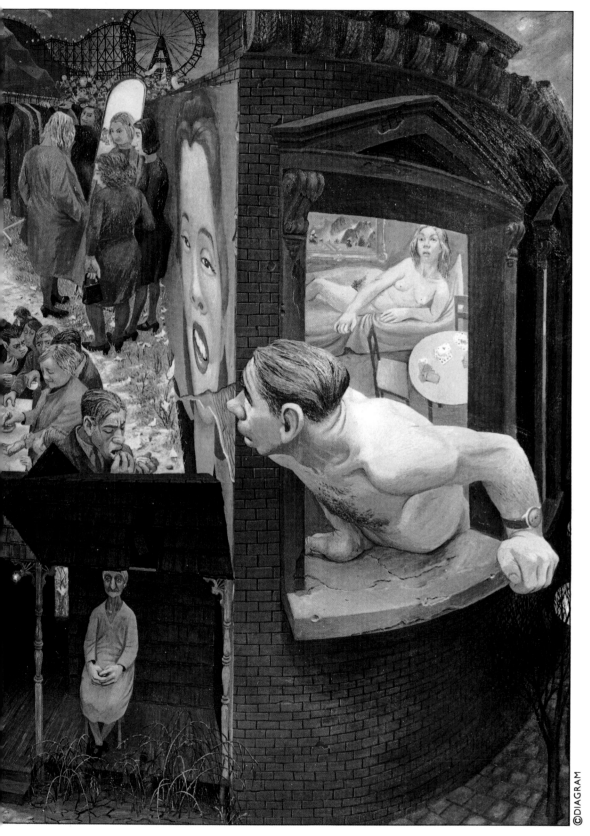

9

The subject of fantasy

Every picture tells a story, and none more so than those made by fantasy artists. The origins of these visions may be buried deep inside our memories but their ideas spring from folklore and mythology, dreams and the bizarre aspects of reality. Although almost always painted with very close attention to realism, they are unreal, the workings of imagination overpowering the perceived world, creating a suspended reality.

Unseen worlds
Story-telling by adults is a universal and ageless way of conveying ideas. The story-teller (*right*) uses his arms to describe a monster's actions, invoking the children's imaginations so they 'see' the demon's threat. Fantasy images begin in the mind and not in reality.

Old worlds (*right*)
European artists have always been inspired by myths and symbolism. The Greek myth of Hercules fighting Achelous (as a bull) is also recorded in Asian cultures, and in sculpture, on vases and on walls. For a thousand years animals symbolized the evangelists – St Mark appeared as a winged lion.

New worlds
The European discovery of America opened up new sources of myths and images such as this Aztec god (*right*). Psychologists in the 20th century think that although the images produced by different cultures vary greatly in appearance, the subjects they portray are universal.

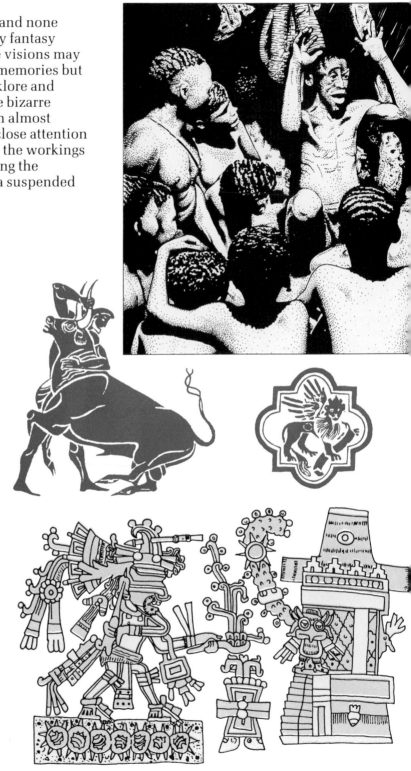

Dream worlds

The picture (*right*) is of a nightmare experience of the Spanish painter, Francisco de Goya. In 1810 he was recovering from an illness which had left him deaf. The inner silence heightened his imagination and this new experience helped him link his visions to his observations of the human condition.

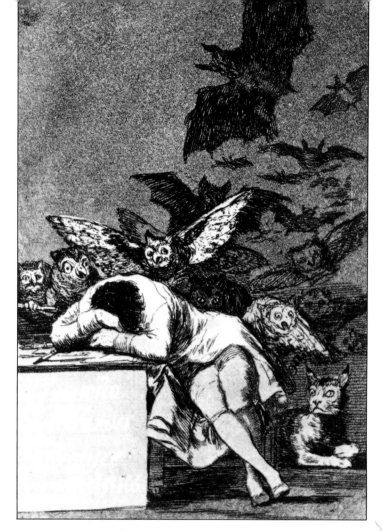

Productive worlds

The English 19th century author Charles Dickens (*right*) created stories for weekly publications. His ideas often arose from observation and the quiet contemplation of the fire or carpet patterns. He worked with his memories to forge new worlds in which his creations took on real form.

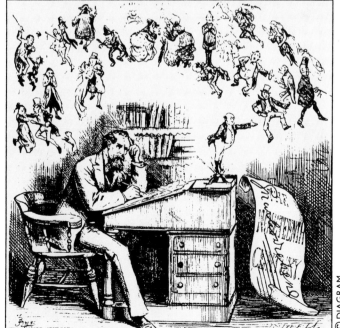

Picture sources

Ideas have legs; they creep up on you, or jump out of the most unexpected places. Do not sit waiting for inspiration. Collect images all the time, store up discoveries, review other artists' work. When not directly working on a finished drawing, experiment with unfamiliar techniques. The successful artist explores all possible sources and turns them to his advantage.

Artists' sources

A continuous stream of inspiration is provided by the work of other artists. Do not be embarrassed to copy ideas, techniques, themes, details and mannerisms. The drawing (*above right*) is by Ivan Bilibin, a Russian whose illustration is derived from 19th century popular Russian folk art.

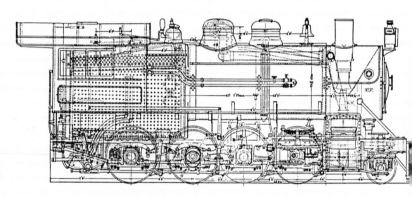

Technical sources

The most surprising and varied sources of imagery are technical publications, on engineering or micro-biology, industrial catalogues or academic text books. The unfamiliar can be a starting point for your drawing. Many fantasy artists have used bizarre diagrams from surgery manuals as inspiration for horrific visions. The transparent study of a railway engine (*above right*) can throw up ideas for futuristic machines. The microscopic creature (*right*), enlarged a thousand times, could be the start of a galactic monster.

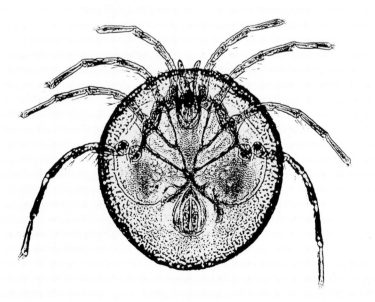

Photographic sources

Photographs are an infinite storehouse of images. Postcards, magazines, books, posters and movie stills can stir the imagination. Photography is particularly helpful in painting realistic detail. A simple view of a building (*right*) can provide ideas for a fantastic palace.

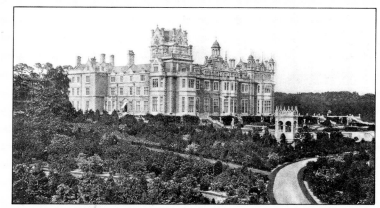

Exploration

There are two sources of ideas available while you are actually working on your drawing: discoveries made either while drawing or during printing. Different tools, surfaces, media and processors can all provide methods of exploring accidental results. The word 'DANZIG' (*right*) was altered by first drawing the characters in a slow-drying ink and, before it dried, blowing through a drinking straw at the wet ink strokes while moving the paper around. Textures often have a graphic quality which is stimulating. The granular surface (*right*) is produced by the break up of the protective coating on metal before applying an etching acid. The distorted manuscript (*right*) is the result of holding part of the original image away from the surface of the photocopying machine. These technical methods have produced results which can inspire your later designs.

©DIAGRAM

Studying nature

The natural world is one of the most commonly-used inspirational sources for the fantasy artist. The great Renaissance painter Leonardo da Vinci instructed pupils to observe: "You should look at certain walls stained with damp or at stones of an uneven color. If you have to invent some setting you will be able to see in these the likeness of divine landscapes." He suggested "you should look at the embers of fire, or clouds, or mud, or other similar objects from which you will find ideas . . . because from a confusion of shapes the spirit is quickened to new inventions." Natural shapes are everywhere – plants, animals, rocks, water. To absorb ideas from them you must pay close attention to the surface detail and record what you see with great accuracy.

Plant sources
The plant kingdom produces thousands of wonderful shapes, textures and colors. The minute seed pods (*left*), the diseased acorn (*below*), the roots of an orchid (*bottom*) or the spiky limbs of a cactus (*below right*) are exciting beginnings for a fantasy image.

Surface sources (*opposite*)
By drawing carefully the details of the surface of a leaf and an old piece of wood (*above* and *far right*), Lee, aged 18, has produced a drawing which can later become a landscape. Jane's pencil study (*below*) of a cut cabbage already looks like a magic tree.

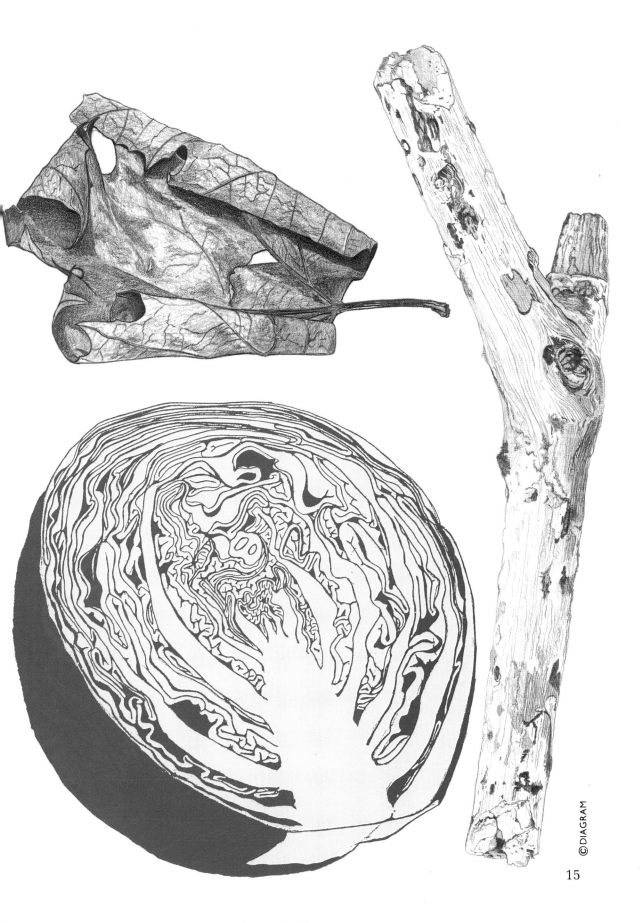

15

Using reality

Leonardo da Vinci's advice to students
(page 14) was echoed 300 years later by
the English poet William Blake.

To see a World in a Grain of Sand
And a Heaven in a Wild Flower,
Hold Infinity in the palm of your hand
And Eternity in an hour.

This poem is about the details of life, the
tiny surface qualities of reality; while
examining them consider the worlds
beyond reality, in our imaginations.

Using everyday objects (right)
The close inspection of three
objects – a corkscrew, a fish
head and a loaf of bread –
reveals that each has
different qualities that can
be built up to create a new
world of fantasy (as you can
see on page 72).

Your own inspiration bank
By collecting objects, you
will have a library of images
which can spark off ideas.
When out walking, or while
cleaning out tool boxes –
whenever your attention is
caught by the unique
qualities of small objects –
try to collect them. By
displaying them in a wall-
case (opposite), you will
create your own personal
bank of shapes and textures
which it would be otherwise
difficult to imagine.

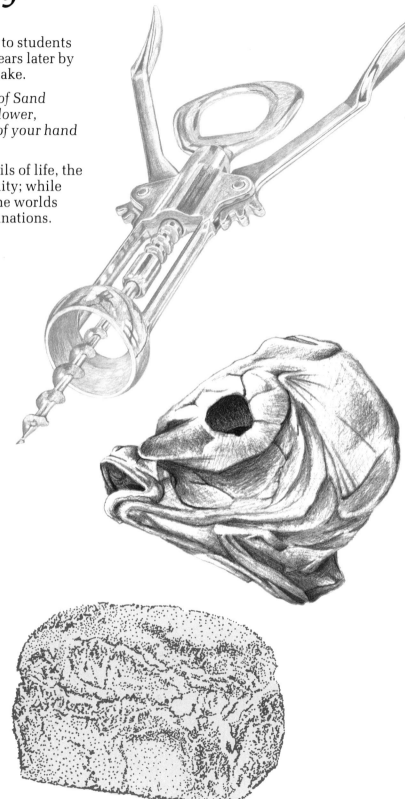

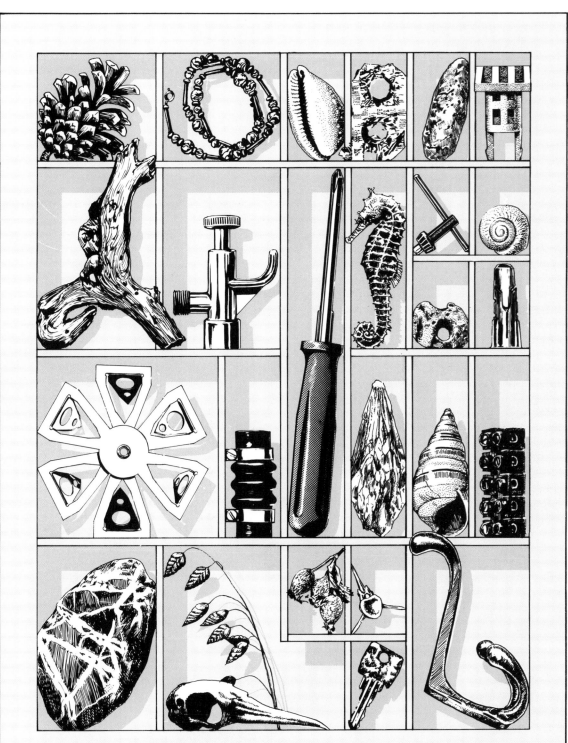

Using manufactured objects

Objects made by machines, particularly with 20th century materials, have an artificial, unnatural form and texture – plastics, rubbers, artificial fibers, metals – all have a 'man-made' quality. Advancing technology means that their forms need not comply with natural laws of structure and growth. Materials which are molded, extruded, printed, cast, burnished, glazed, galvanized, polished, coated, fused together, all possess interesting shapes and surfaces which are easily available for study and which can stimulate ideas for pictures.

Materials (*right*)
1 The rubber drive-belt from a vehicle is formed in one piece. Its springy resilience when put on a flat surface creates new shapes and ideas for spatial patterns.
2 The metal sugar bowl (the drawing was copied from a photograph in a mail order catalog) has a highly reflective surface which can be used in the creation of space stations.
3 The commercial scrubbing brush, from a trade catalog, offers ideas for unnatural plant textures.
4 The simple study of a spiral telephone cable will help in the drawing of more realistic bodies of monsters or parts of futuristic machines.

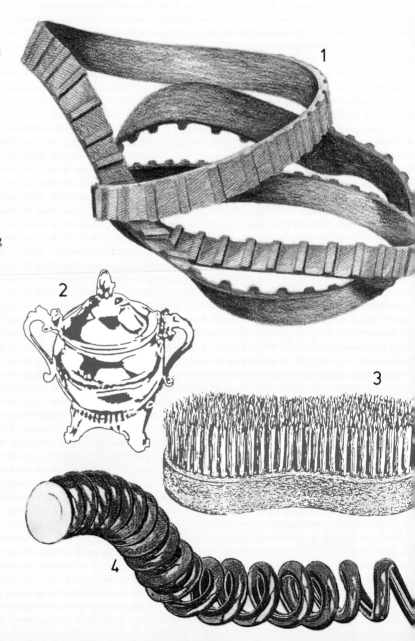

Forms
Industrial tools make wonderful models for inventing space-age weapons. The drawing (*above*) was made by David from a collection of examples of craftsmen's tools (*right*), published in a trade catalog.

Scale
The minute scale of printed electronic circuits (*below*) can be enlarged to stimulate visions of city plans of the future, or the inner workings of a new robotic creature.

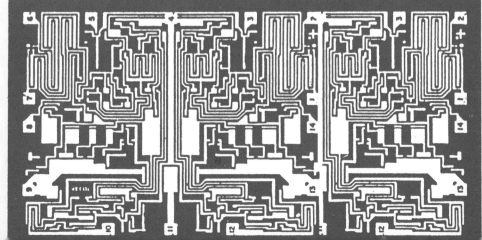

19

The unseen world

There are new frontiers in the production of images that provide wonderful opportunities and inspiration for fantasy worlds. Realms unseen by previous generations appear in specialized textbooks. Microphotography enlarged, computer pictures, instructional diagrams, or images of long-lost existence may all startle and surprise with their freshness and revelations of worlds previously hidden from us.

1 Evolving worlds
This fluffy chick is seen through a hole in its egg. Its beak and claws are large in comparison to the rest of its body. With imagination, this could be turned into a monster asleep in its lair.

2 Past worlds
A technical reconstruction of a marine creature from the Devonian period, about 400 million years ago, could inspire the design of a futuristic fighter space-ship.

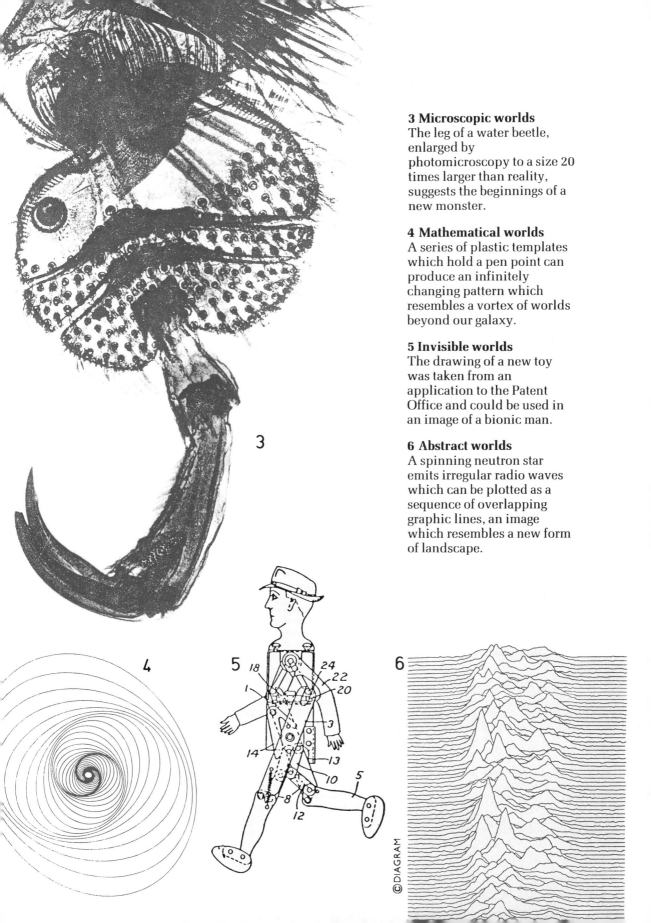

3 Microscopic worlds
The leg of a water beetle, enlarged by photomicroscopy to a size 20 times larger than reality, suggests the beginnings of a new monster.

4 Mathematical worlds
A series of plastic templates which hold a pen point can produce an infinitely changing pattern which resembles a vortex of worlds beyond our galaxy.

5 Invisible worlds
The drawing of a new toy was taken from an application to the Patent Office and could be used in an image of a bionic man.

6 Abstract worlds
A spinning neutron star emits irregular radio waves which can be plotted as a sequence of overlapping graphic lines, an image which resembles a new form of landscape.

©DIAGRAM

Exploiting photographs

Visual ideas and details can often be found in photographs which, without clear visual references, might prove difficult to invent. Most artists have extensive collections of photographed material which they have built up of the subjects that particularly appeal to them. Reality, too, can be used as a source, so always try to photograph places and lighting effects you find interesting.

Photographic sources (*above*) Newspapers, magazines, old books, specialized publications, postcards, all yield telling images. Arrange your collection in sections so that you can find a particular subject later: landscapes, buildings, figures, objects, or general topics like compositions, lighting effects or the bizarre.

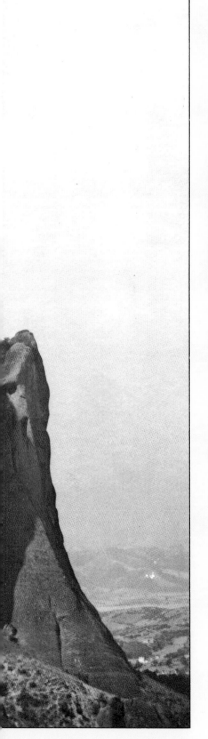

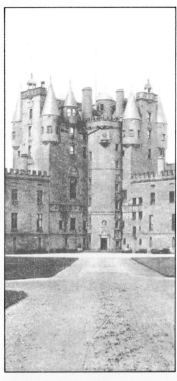

The real into the unreal
The photograph (*left*) was
taken while I was on holiday
in northern Greece; such a
startling cliff needed to be
recorded for later use. The
19th century Scottish castle
(*above*) is a fairytale
building come true. These
pictures were combined in
the creation of an illustration
for a comic book series
(*right*).

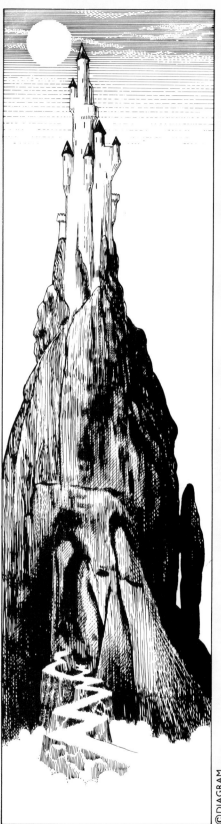

©DIAGRAM

23

Using your own photographs

The camera can be a tool, just like a brush or pen. You can use its ability to record detail as a means of sorting out the visual qualities of your ideas. Begin by first sketching your intentions, then when you feel confident with an idea, use the camera on location or in fixed lighting to build up your knowledge of the subject.

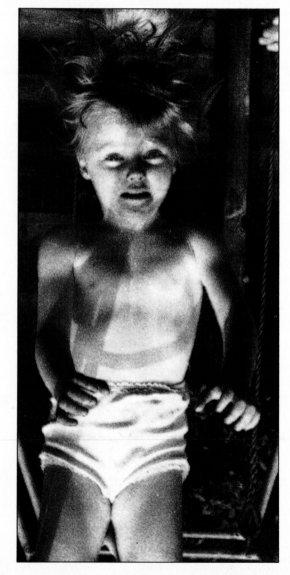

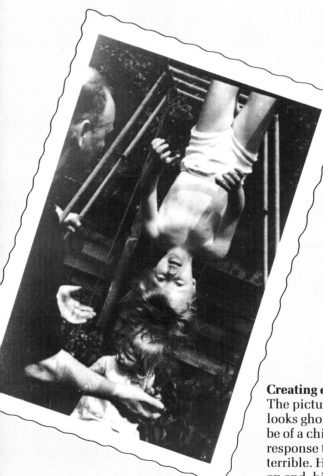

Creating effects

The picture (*above right*) looks ghoulish; it appears to be of a child's frightened response to something terrible. His hair is standing on end, his hands are grasping out and the light comes from below. The total effect is one of horror and mystery. In fact, the photograph was taken of the child while he hung upside down on a park swing (*above left*).

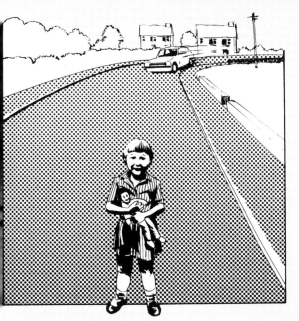

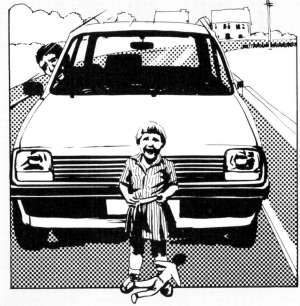

Building tensions
The photograph (*left*) is of a stationary car with a small child standing in front of it. It could be used for the creation of two sequential drawings involving a car accident (*above*).

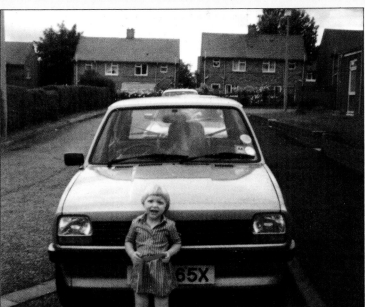

Sand writing
Most artists would find it difficult to record accurately letters written in sand. A way of providing yourself with a visual reference is to write the letters in a tray of sand, then photograph it with a strong side light (*left*).

© DIAGRAM

Using models

Artists have often built models of parts of objects they want to draw in their search for interesting views. Present-day construction kits provide replicas of details which would be time-consuming to build. A model can be modified and views of it explored either with a camera or with sketches. This technique is often used for studies of figure drawings. In strip cartoons, constructing models helps you to memorize special features.

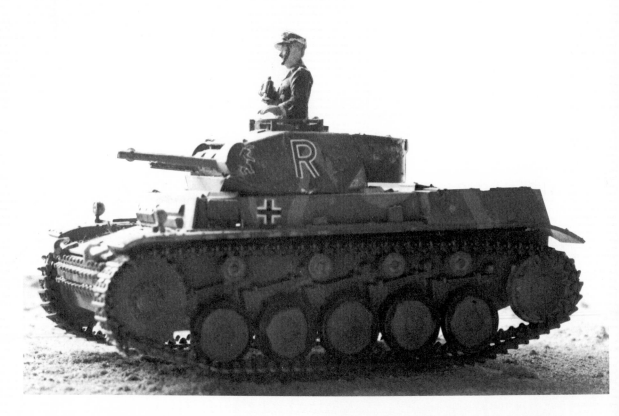

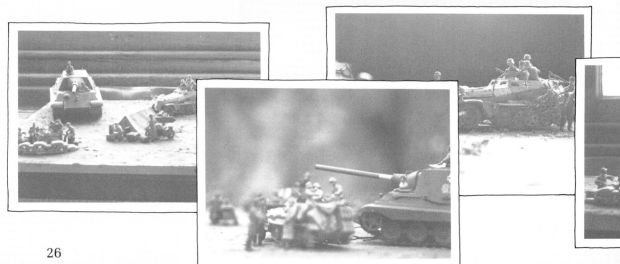

Comic artwork
The action-packed small drawings (*right*) are the result of building on the photographic impressions of the models and fantasizing on the static compositions of the objects.

World War II battles
The model of the tank Pzkpfw II from a purchased construction kit was made by Michael, aged 15. From this and other models he was able to take photographs (*opposite*) from different viewpoints, and also to arrange the objects in a variety of ways so as to arrive at interesting compositions (*below*).

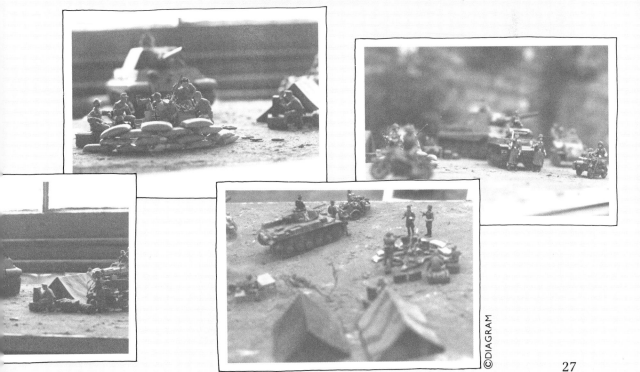

27

Using other cultures

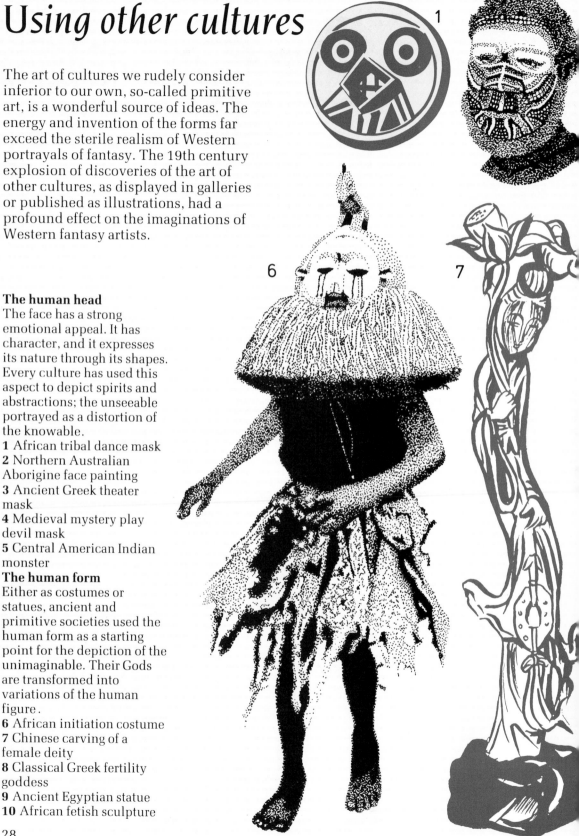

The art of cultures we rudely consider inferior to our own, so-called primitive art, is a wonderful source of ideas. The energy and invention of the forms far exceed the sterile realism of Western portrayals of fantasy. The 19th century explosion of discoveries of the art of other cultures, as displayed in galleries or published as illustrations, had a profound effect on the imaginations of Western fantasy artists.

The human head
The face has a strong emotional appeal. It has character, and it expresses its nature through its shapes. Every culture has used this aspect to depict spirits and abstractions; the unseeable portrayed as a distortion of the knowable.
1 African tribal dance mask
2 Northern Australian Aborigine face painting
3 Ancient Greek theater mask
4 Medieval mystery play devil mask
5 Central American Indian monster

The human form
Either as costumes or statues, ancient and primitive societies used the human form as a starting point for the depiction of the unimaginable. Their Gods are transformed into variations of the human figure.
6 African initiation costume
7 Chinese carving of a female deity
8 Classical Greek fertility goddess
9 Ancient Egyptian statue
10 African fetish sculpture

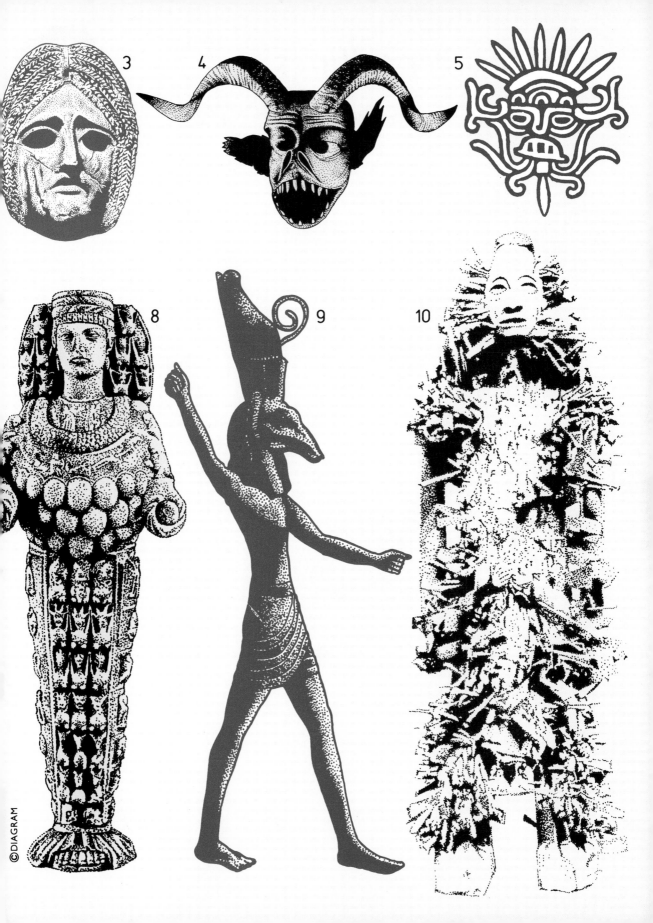

Past masters

In the mind of a master artist images float to the surface of his consciousness and are captured for eternity in his art. You should never be embarrassed about copying their discoveries for your own use. They, too, have used previous creative artists as inspiration. But when copying the work of others, you should develop your own ideas beyond the original source, using it as a starting point.

The spread of images
Artists have been creating fantasy images for thousands of years. However, it is only during the last five hundred years (with the advent of printing) that the images have been spread among a wider audience.

1

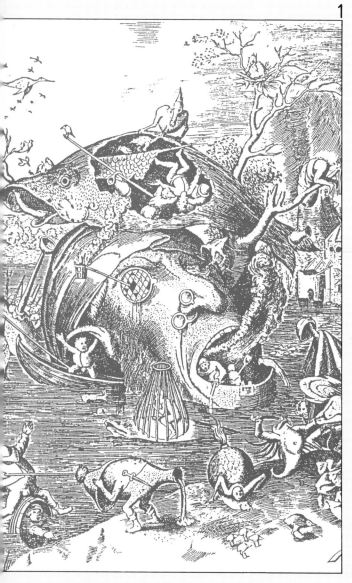

2

Graphic Art

Five examples of the work of great graphic artists in the world of fantasy:

1 The 16th century artist Peter Brueghel the Elder. A detail from an engraving entitled '*The temptation of St Anthony*'. Compare this with examples on pages 38-39, 40, 54-55 and 62-63.

2 The 18th century artist William Blake's drawing of a vision he had while considering quotations from the bible.

3 A detail from the work of the 19th century artist Gustave Doré, whose imagination was stretched by illustrating works of literary fantasy.

4 A detail from a drawing by the 19th century Japanese artist Katsushika Hokusai. His hundreds of drawings of everyday life in Japan greatly helped his drawing of imaginary subjects.

5 Unidentified artists' covers for popular magazines, showing a variety of 20th century illustrations of popular comics and magazines.

3

4

©DIAGRAM

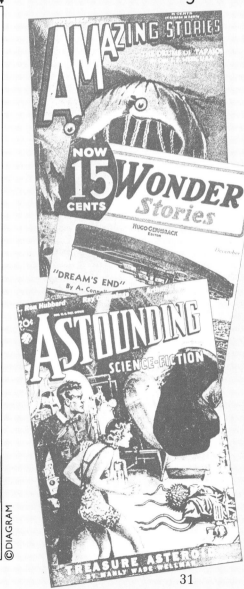

5

31

Section Two
Sources of fantasy

I once overheard a beautiful conversation between two children, one aged six and the other ten years old. The eldest was explaining that comics have words in them for people who cannot read the pictures!

Fantasy pictures have a meaning. Understanding the pictures is a major part of enjoying such works of imagination. Very often when we discover new forms of fantasy art we have difficulty in 'reading the picture.' The roots of the ideas and forms dig deep into many levels of human experience, and this section of the book examines a selection of these sources. They may come from events in our daily lives, the forms of nature, or from the subconscious world of our dreams. They may have their origins in the collective, subconscious, world of mythology, superstition, folklore and religious symbolism. Or they may simply be the playful self-indulgence of the artist exploring his own imagination.

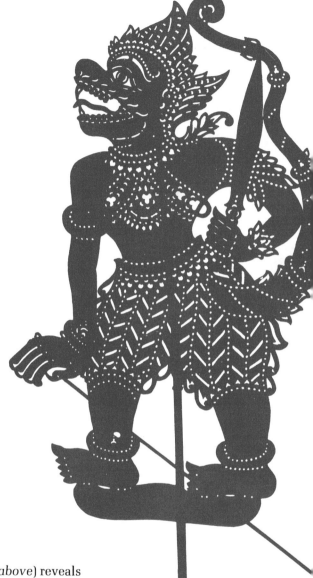

The picture (opposite) by the Belgian painter James Ensor uses our knowledge of medieval and 19th century comic pictures to portray evil. We know that the figures surrounding his self-portrait are threats to his sanity, and that somehow (we don't fully understand his private code) the central cockerel is an inspiration and guiding light.

The figure (above) reveals our ignorance of the image languages of other cultures. Is it a man or a woman? Is it a threat or a comfort? To the Malayan audience, who understand the shadow puppet figure, it is simply a matter of their collective understanding of representations of good and evil, heroes and villains and servants and kings. This figure is Hanuman, a hero.

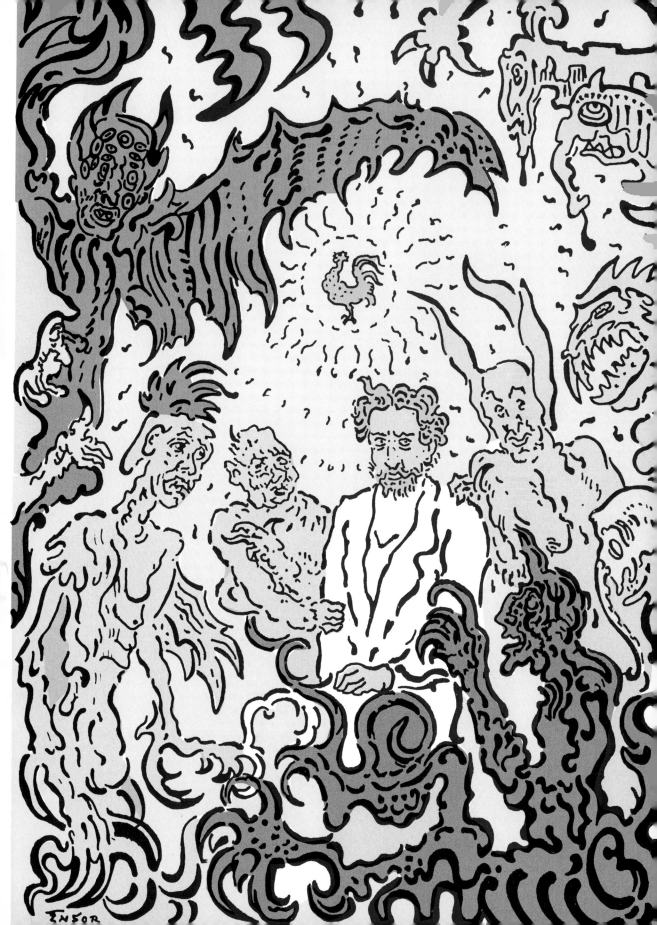

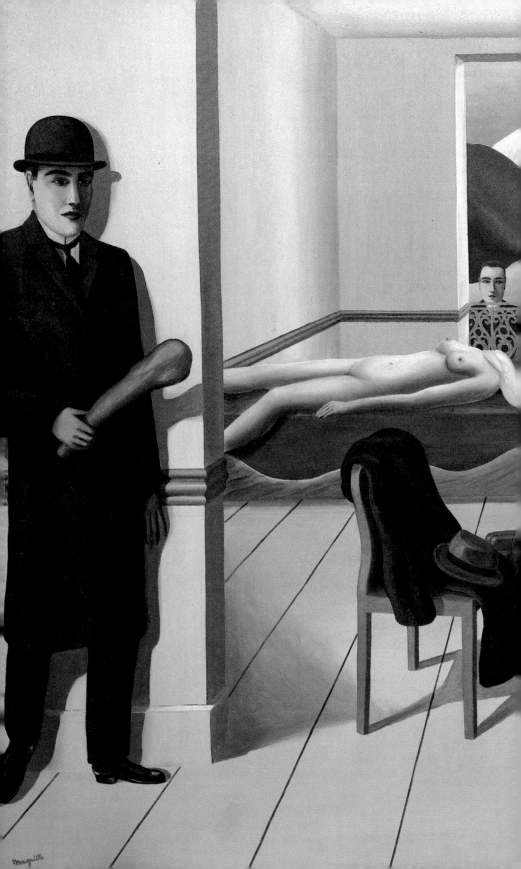

Fantasy of the ordinary

Normality is an excellent source of fantasy art because it is everywhere, always available, and because of its familiarity. The effects are usually achieved by juxtapositions of incongruous objects and ideas of inverted normality. The elements in a picture are often arranged as if asking you to make up your own story of the preceding events. This form of art can have a very successful impact, as though casting a spell over the observer. We know reality is around us, and we are always disturbed by abnormality because it forces us to re-adjust our accepted impressions.

Preceding pages:
The menaced assassin
Magritte, 1926

This picture draws its ideas from the silent movies and popular detective fiction of the 1920s. One series of films, *L'époque de Fantômas*, was a particular favourite of Magritte. The films portray the exploits of a master criminal who appeared and disappeared with unreal ability, an effect engineered by cinematographic techniques. Episodes were invented by two authors, taking it in turns to write alternate chapters. During the 1920s Magritte explored many ideas of reality and illusion, producing paintings at the rate of one a day. Every one was like a new hallucinatory vision, irrational and absurd, a purveyor of the paradoxical.

Horror sources
A great source of fantasy art is the depiction of horrific events. This 19th century illustration (*below*) is of a particularly gruesome child murder. The retreating back of the man, the child's smiling head on the table, the trail of blood from the body under the bed, all set in a normal interior, produce an impression of involuntary and perverse action, the work of a madman.

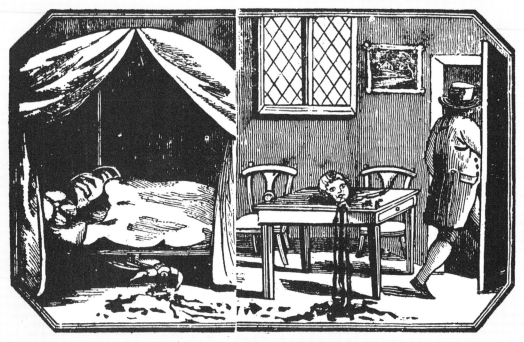

(Preceding page) Collection, The Museum of Modern Art, New York, Kay Sage Tanguy Fund.

Juxtapositions

In the 19th century, popular postcards used arrangements of figures and objects to suggest unusual meanings, a kind of sexual hint by association. The drawing (*right*) by the 19th century Belgian artist Felicien Rops suggests a sexual relationship between the fireman's hosepipe and the nude figure.

©DIAGRAM

Heightened normality

The drawing (*right*), entitled *The death chamber*, by the Norwegian artist Edvard Munch, shows the interior of a bedroom in 1892. Although we cannot see the person in the bed, we assume from the positions and expressions of the other people in the room that they are considering the finality of death.

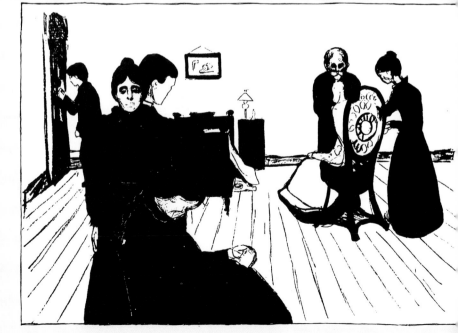

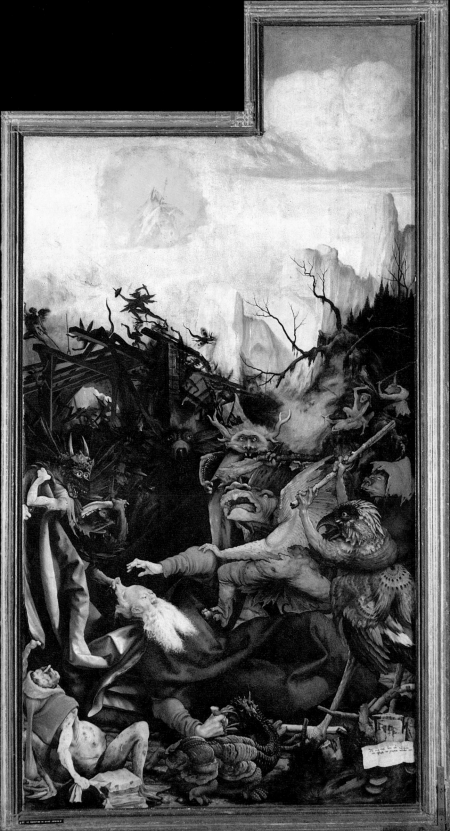

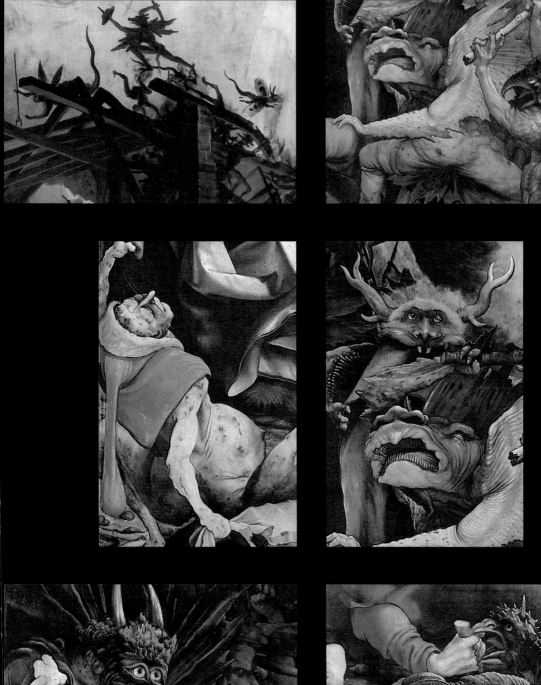
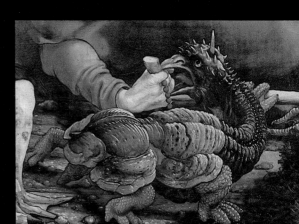

Fantasy of nature

"Such tricks hath strong imagination
That if it would but apprehend some joy. . .
Or in the night, imagining some fear,
How easy is a bush supposed a bear?"
from Shakespeare's great fantasy play on
nature, *Midsummer Night's Dream*.
Nature has always been a source of
fantasy for artists. The complex forms of
plants and animals can be used to
describe imaginary worlds. Trees can be
spirits, animals can behave like humans,
heaven or hell can be landscapes
derived from earthly places.

Zoomorphic monsters
The wood-engraving (*below*)
is by a contemporary of
Grunewald, Albrecht Dürer,
and shows another
Temptation of St Anthony.
The tangled web of living
forms is culled from
observations of insects,
crustaceans, birds, reptiles
and mammals.

Preceding pages:
The temptation of St Anthony
Matthias Grunewald, 1510

The painting and details
(*over*) are on an altar panel.
The trees, plants and
creatures are from the dark
forests of Germany, the
home of wolves, demons and
evil spirits. The monsters are
a strange mixture of animals,
some slimy, some feathery,
some scaly and some with
human flesh. They behave
like freaks; they hiss, fight,
bellow at St Anthony and at
each other; they torment and
are tormented; they are
disfigured and diseased. The
monster (*lower left*) has
leprous or syphilitic skin
blisters. Grunewald's
painting, like the Bosch
Temptation on pages 54-55,
was directed at sufferers. But
its message is that self-
inflicted suffering, brought
on by evil acts, especially
those directed at St
Anthony's religious order,
cannot expect intercession
from a patron saint.

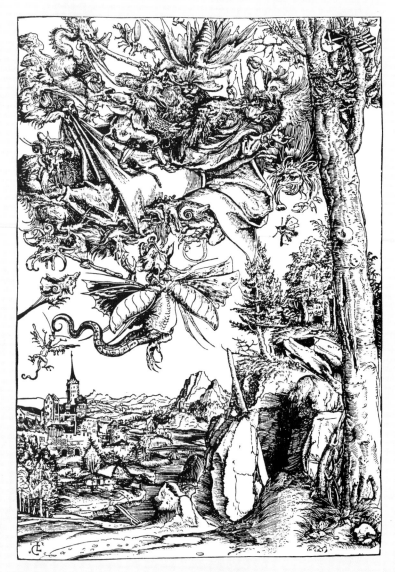

Plant spirits

Book illustrators have often used fairy tales, with their sense of magic, to create fantasy from small details in nature. A tangled bramble bush can be transformed to contain hidden forest spirits (*right*). Cabbage-like leaves (*below right*) can grow from the limbs of a reclining nude.

Animal spirits

The North American West Coast Indians attribute to animals a spirit form which is then painted on their houses, objects and garments to create an imaginary world of spirit animals. The two (*below*) show a killer whale and a beaver.

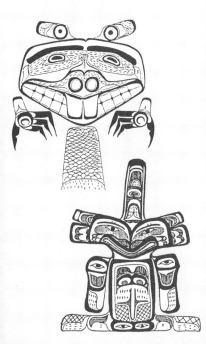

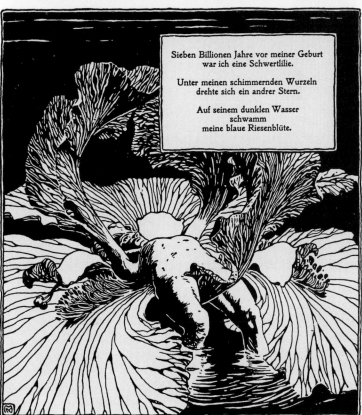

Sieben Billionen Jahre vor meiner Geburt
war ich eine Schwertlilie.

Unter meinen schimmernden Wurzeln
drehte sich ein andrer Stern.

Auf seinem dunklen Wasser
schwamm
meine blaue Riesenblüte.

©DIAGRAM

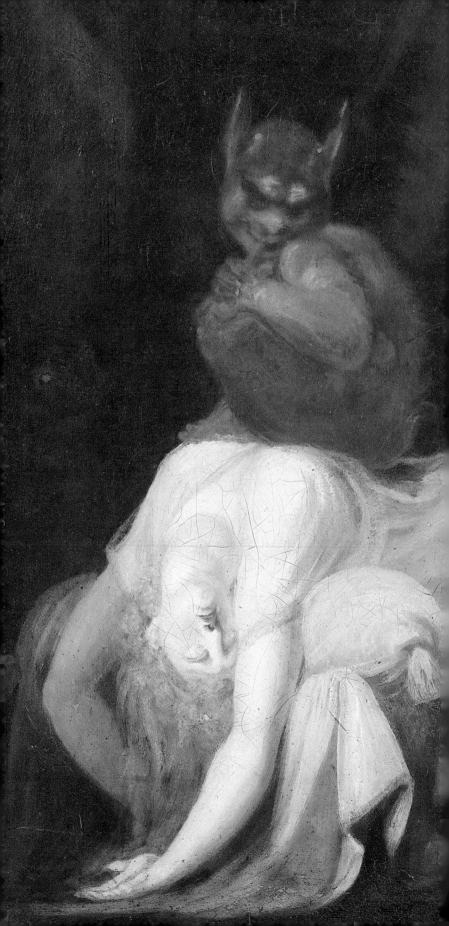

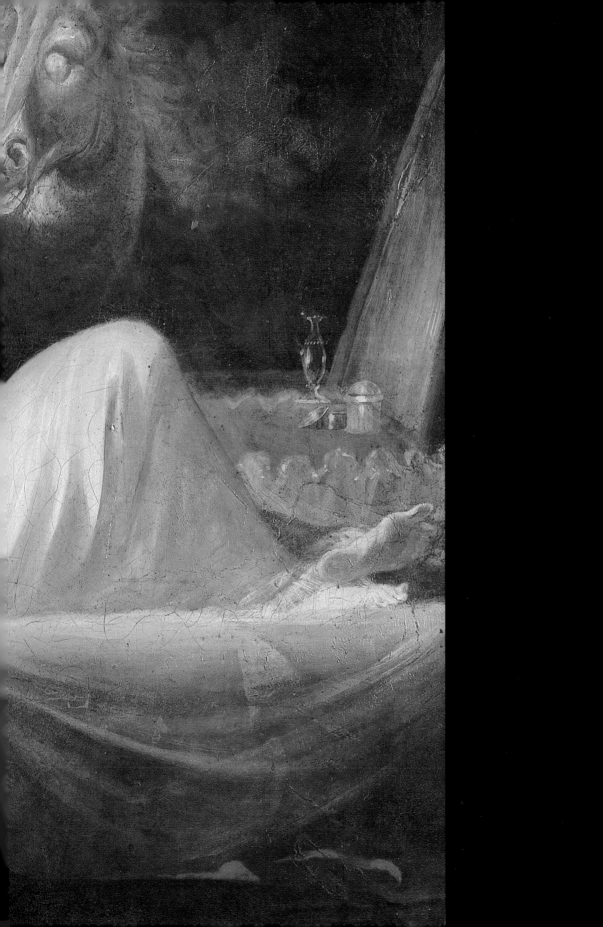

Fantasy of dreams

Dreams can be the gateway to imagination. Their inner world can be a well of ideas for fantasy artists. The creation in literature of the monster Frankenstein was the result of a dream by its author, Mary Shelley. Many artists and authors have kept a pencil and paper by their beds so that, on waking, they could write down the new ideas and images which appeared in their dreams. In the 20th century many psychologists have interpreted our dreams and fantasies as unfulfilled secret ambitions and fears. For whatever reason we dream, the images are dazzling in their nonconformity to reality. Space, form and time are all suspended in the mirror of our sleeping minds.

Preceding pages:
The nightmare
Henry Fuseli, 1781

Shortly after completing this picture, Fuseli wrote to a friend that he had dreamed of how he had made love to his unrequited sweetheart, the lady believed to be the subject of this picture. He painted a series of these subjects, each illustrating a young girl's dream, but most likely depicting his own fears and anxieties. The girl in Fuseli's painting is believed to be experiencing an imaginary sexual assault. Fuseli's other versions of this subject were thought to be commissions for private bedrooms. Copies of this subject were sold as popular engravings, and its sense of intimate privacy was turned into a jesting, joking, crude ridicule of a young girl's fantasies.

Dream lands
Children's fiction abounds with dream worlds. Peter Pan, Little Nemo and Alice were all set in the dreams of children. The illustration (*above*) is from the 19th century story *At the Back of the North Wind*, in which a boy's harsh life is made bearable by his adventures travelling with the fictitious north wind lady. The series (*left*) is from the American newspaper cartoon, *Little Nemo in Slumberland*, by the great fantasy artist Winsor McCay.

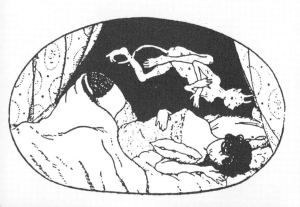

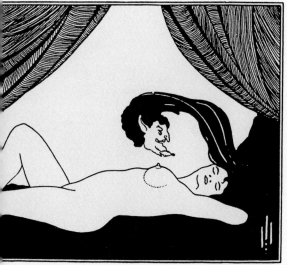

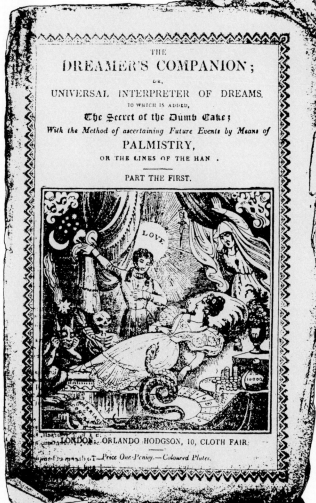

Tempting devices

Each of the two 19th century illustrations (*above*) portrays a girl being visited by an incubus. This creature was a demon who visited sleeping females with offerings of seductive thoughts and emotions.

Interpreting dreams

The dreamer's companion (*above right*) was a popular 1840s interpretation of dreams, and was consulted by girls as a guide to their future.

The source of dreams

This 16th century diagram (*right*) illustrated contemporary ideas on the root origins and causes of dreams. These quasi-medical plans confused physical features with the spiritual and ethereal. Medieval thinkers often maintained that dream images were a dialogue with supernatural forces or the voice of God.

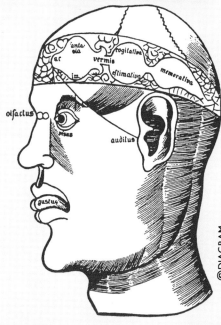

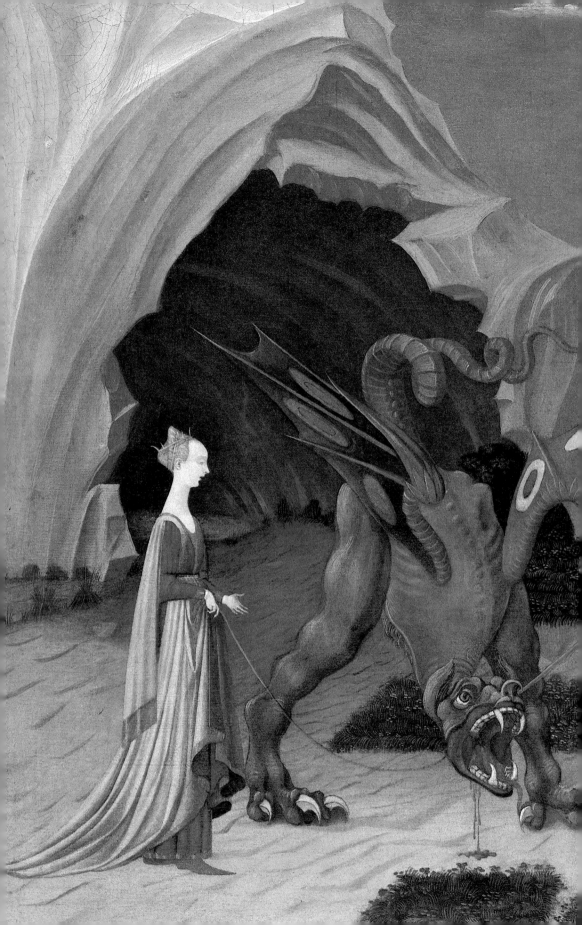

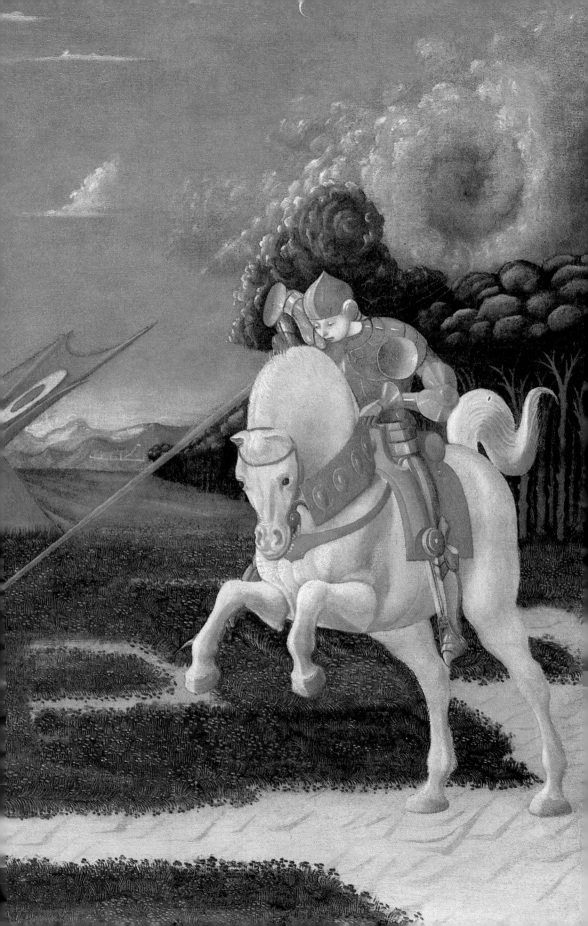

Fantasy of legends

Centaurs, harpies, satyrs, Cyclops, griffins, unicorns and dragons are all conjured out of mythology. The characters and exploits of these early fantastic creatures have been used over and over again by later artists. Legends are re-interpreted by each age and a benign being, which was once a symbol of goodness, can become a focus of evil, a vision of wickedness. Greek gods, Egyptian deities, legendary Roman heroes and Nordic spirits have been re-born in later Christian belief to represent similar or parallel attributes. It is only in the late 19th and 20th centuries that we have become aware of the mythologies of Asia, Africa and the Americas, the imagery of which has not yet been incorporated into our visual language.

Preceding pages:
Saint George and the dragon
Paolo Uccello, 1456

The legend in which St George rescues a maiden by slaying a dragon was a popular subject for both paintings and sculptures. To both artist and audience alike it symbolized the struggle between good (the hero) and evil (the monster), and asserted that virtue and innocence (the maiden) cannot be harmed by evil. Uccello worked in a Christian environment, decorating churches and the homes of devout princes. The use of classical and mythological subjects as symbols to express Christian beliefs was very common during the Renaissance.

Re-inventing mythology
The 19th century English author Lewis Carroll introduced a new audience to past legends. In the illustration (*right*) the artist John Tenniel depicts a youthful hero battling with a reptilian dragon. Tenniel's visual inventions were ideal for the world of Carroll, and their collaboration makes the stories about Alice everlasting classics of fantasy.

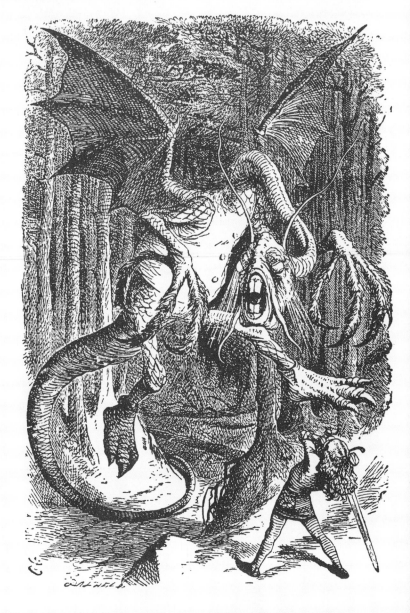

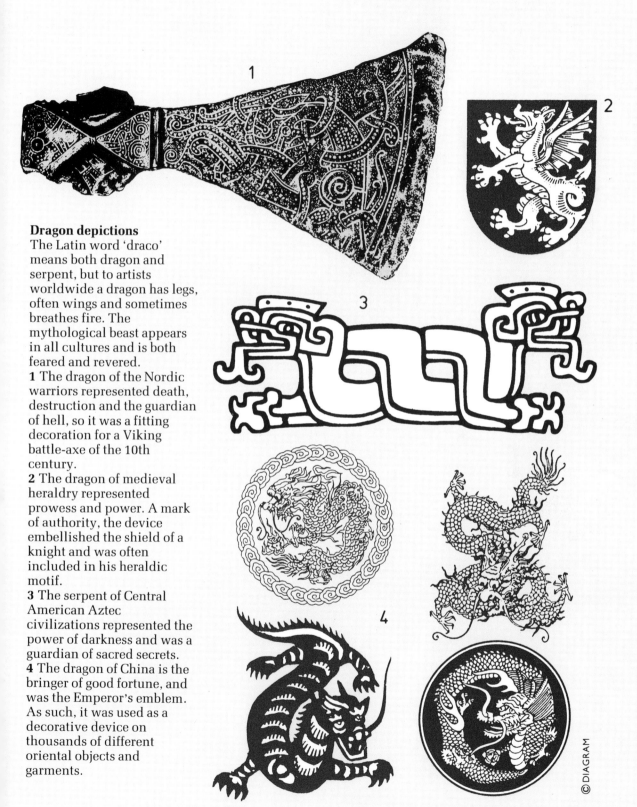

Dragon depictions

The Latin word 'draco' means both dragon and serpent, but to artists worldwide a dragon has legs, often wings and sometimes breathes fire. The mythological beast appears in all cultures and is both feared and revered.

1 The dragon of the Nordic warriors represented death, destruction and the guardian of hell, so it was a fitting decoration for a Viking battle-axe of the 10th century.

2 The dragon of medieval heraldry represented prowess and power. A mark of authority, the device embellished the shield of a knight and was often included in his heraldic motif.

3 The serpent of Central American Aztec civilizations represented the power of darkness and was a guardian of sacred secrets.

4 The dragon of China is the bringer of good fortune, and was the Emperor's emblem. As such, it was used as a decorative device on thousands of different oriental objects and garments.

© DIAGRAM

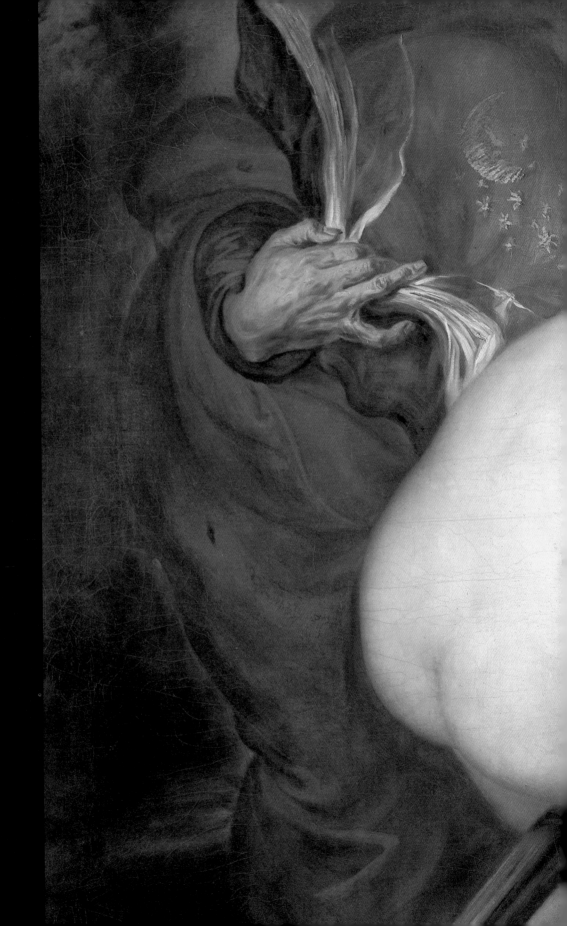

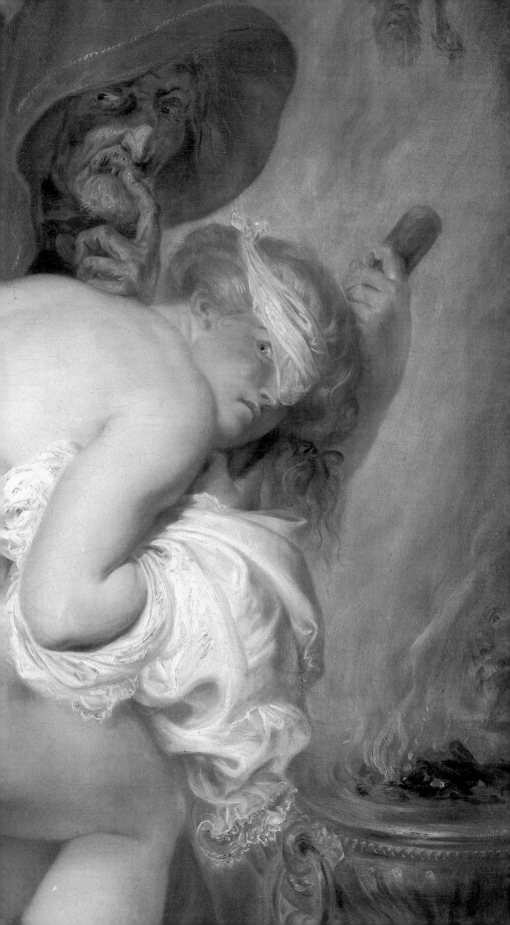

Fantasy of superstitions

Naive belief in supernatural forces has been a common inspiration for fantastic imagery. Superstitions often mix crude, inaccurate tales about demons and devils with the spice of sex and pornography. The stirrings of the lower belly rise to stimulate the imaginings of the mind to create popular fantasy art. Any unexplained event is quickly transformed by folk culture into the machinations of extraordinary forces which are then portrayed as devils, witches, demons, ghosts, vampires and other imaginary beings. The intention of all such inventions is to frighten and to obtain power over the innocent, to capture and fire their imaginations.

Preceding pages:
The young sorceress
Antoine Wiertz, 1850

The detail (*overleaf*) and the full painting (*right*) reveal the opportunities for eroticism in paintings of the supernatural. The artist achieves his effects by skilfully depicting details and by adding disturbing qualities which make us pause and ask questions. What is the old woman teaching the young nude girl to do? Are the other heads those of real observers, voyeurs of pornography, or spirits to help in the ceremony?
Voluptuous flesh caught in an erotic pose combines with the black, cloaked, ancient crone to suggest evil and secret rituals.

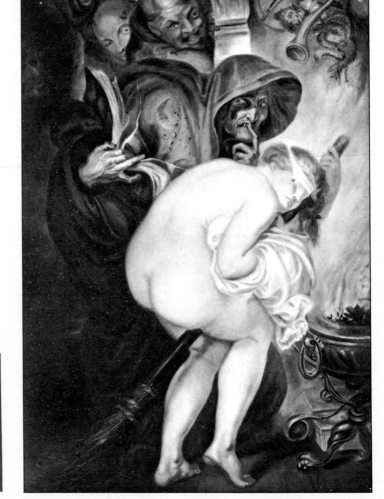

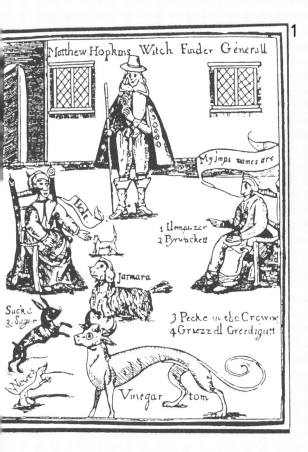

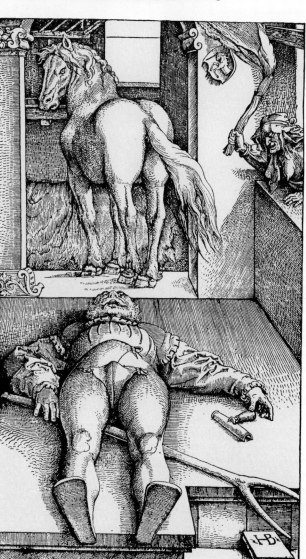

Demonic creatures

Popular tales of devils that tempt young girls or old hags who have power over lives were used by artists to stir up secret fears.

1 *The discovery of witches*, a 17th century book on detecting witches.

2 *The devil and the disobedient child*, an 18th century American storybook illustration on morals.

3 *A bewitched groom*, a 16th century German illustration on the source of illness.

4 *Witches' trail sign* (*opposite*). The tourist highway sign in Salem, USA, commemorates the time when its bigoted citizens allowed superstition to overcome reason and condemned many innocent people to death as witches.

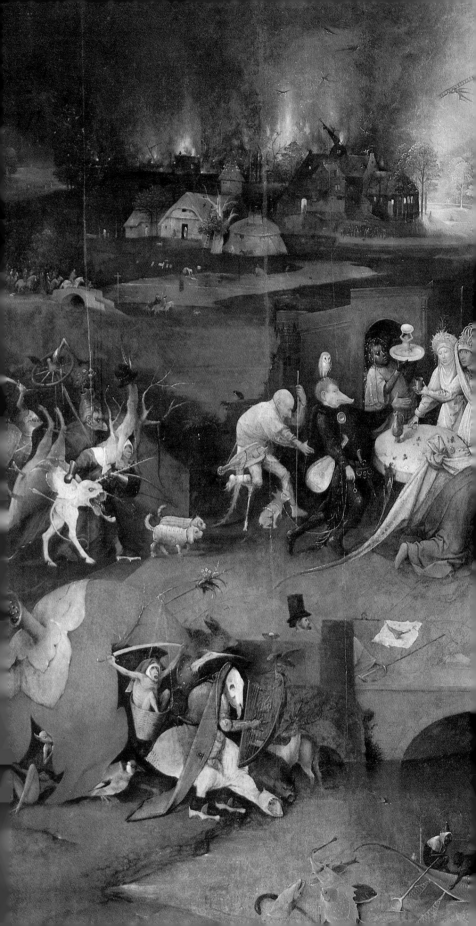

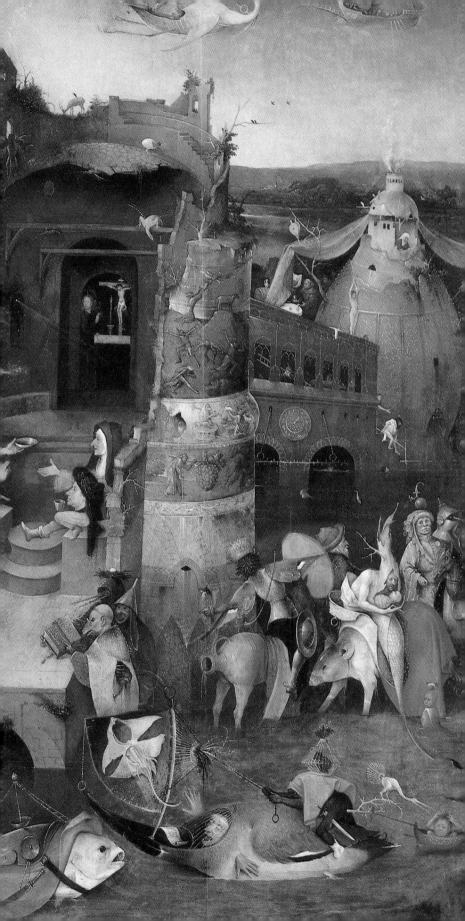

Fantasy of faith

Religious beliefs have provided the means for artists to portray worlds other than the real, physical, observable parts of the Earth. Hindu, Buddhist, Christian, Jewish religious buildings and books abound with fantasy art. The temples of ancient Egypt, Greece, Central America and Asia all contain depictions of fantastic worlds envisioned and drawn by the faithful. With faith, everything is real. Heaven and hell have reality. With faith, emotions can be personalized, shown as individuals, creatures and monsters. To all believers, regardless of education or intelligence, symbolism and pictorial representation are commonly understood. But deeply-held beliefs must continue within any community for pictorial language to convey the artist's ideas; otherwise his visions become obscure and unintelligible.

Preceding pages:
The temptation of St Anthony
Hieronymus Bosch, circa 1500

This painting was requested by the religious order of St Anthony. Attached to its church was a hospital which specialized in treating venereal disease. A sufferer who sought a miraculous cure was asked to contemplate the horrors of evil in front of this painting before being given treatment. The painting is no larger than a dressing-table mirror and only close examination will reveal its details. The many groups, costumes, objects and buildings were intended to convey ideas now lost. Each image is a cartoon of human folly and frailty, many are parodies of Christian beliefs, well-known bible stories, rituals and daily church procedures. The message of the painting is the renunciation of physical delights. Bosch uses symbolic images and puns on common words to convey his warning. Without a profound knowledge of Christian beliefs and practices, the images appear wild and irreverent.

The painting
The altar panels (*below*), when closed, have paintings of Christ's betrayal and crucifixion on the outside. The silhouette of a man's head is shown at the side to give an impression of size.

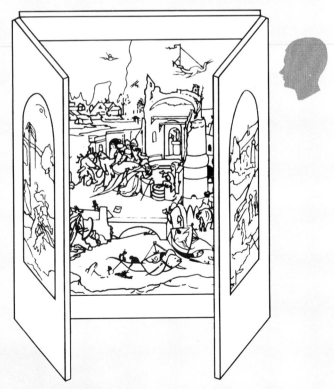

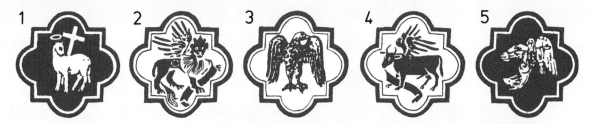

Symbolism

Because so many of the faithful were illiterate, Church leaders used symbols for people in its history. Christ and the four evangelists were often shown as animals or other beings:

1 Christ as a haloed lamb
2 Mark as a winged lion
3 John as an eagle
4 Luke as a winged bull
5 Matthew as an angel

Personification

The seven deadly sins, vices chosen by Christians as the most repellent, were given physical forms: monsters, as in the 16th century German woodcut (*right*), or real animals who were thought to possess an excess of one of the vices.

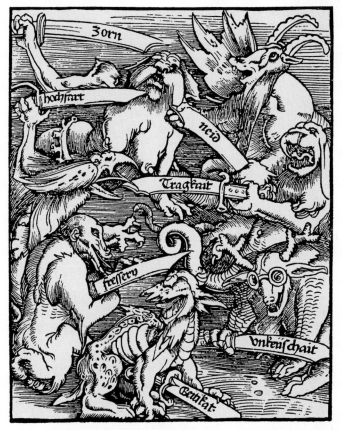

Other worlds

With faith, there is life after death in an existence as real as the earthly one. The early medieval wall painting (*right*) shows the ladder of salvation, a path each Christian must follow to avoid eternal damnation and achieve salvation. Faith makes heaven and hell real; and the emotions, such as hate, love, lust and sloth, have personalities which come alive in the bodies of men, women and creatures.

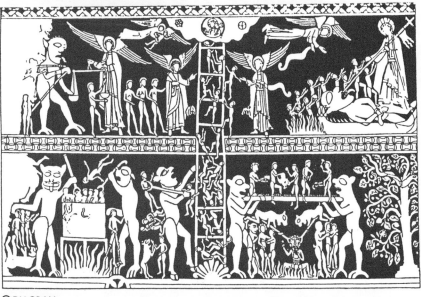

© DIAGRAM

57

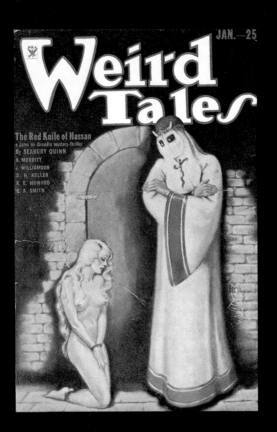

JAN.—25

Weird Tales

The Red Knife of Hassan
a Jules de Grandin mystery-thriller
By SEABURY QUINN
A. MERRITT
J. WILLIAMSON
D. H. KELLER
R. E. HOWARD
C. A. SMITH

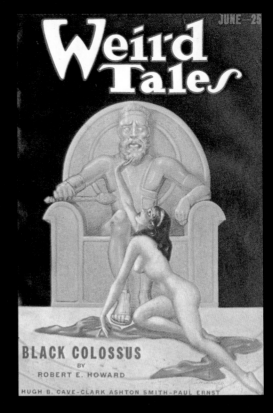

JUNE—25

Weird Tales

BLACK COLOSSUS
BY
ROBERT E. HOWARD

HUGH B. CAVE—CLARK ASHTON SMITH—PAUL ERNST

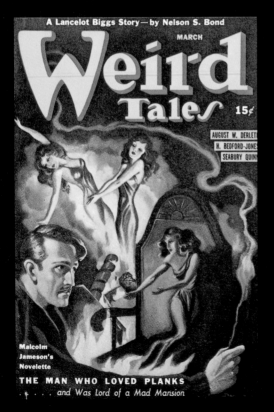

A Lancelot Biggs Story — by Nelson S. Bond

MARCH

Weird Tales

15¢

AUGUST W. DERLETH
H. BEDFORD-JONES
SEABURY QUINN

Malcolm
Jameson's
Novelette
THE MAN WHO LOVED PLANKS
. . . . and Was Lord of a Mad Mansion

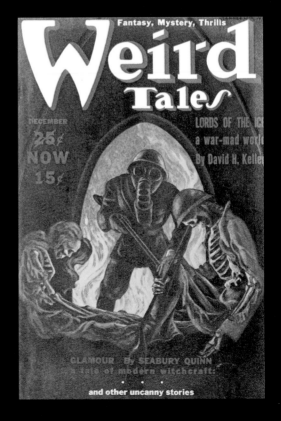

Fantasy, Mystery, Thrills

Weird Tales

DECEMBER
25¢
NOW
15¢

LORDS OF THE ICE
a war-mad world
By David H. Keller

GLAMOUR BY SEABURY QUINN
tale of modern witchcraft
· · · ·
and other uncanny stories

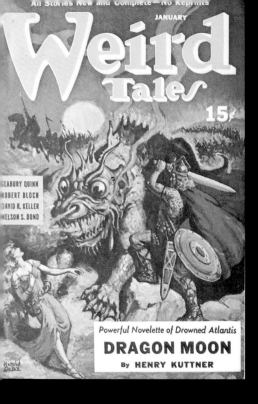

All Stories New and Complete—No Reprints

JANUARY

Weird Tales

15¢

SEABURY QUINN
ROBERT BLOCH
DAVID H. KELLER
NELSON S. BOND

Powerful Novelette of Drowned Atlantis

DRAGON MOON

By HENRY KUTTNER

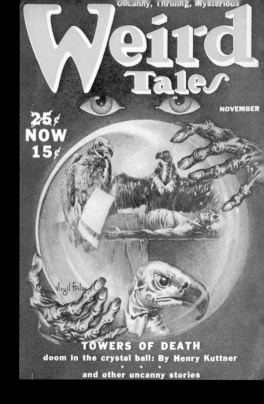

Uncanny, Thrilling, Mysterious

Weird Tales

NOVEMBER

25¢
NOW
15¢

Virgil Finlay

TOWERS OF DEATH

doom in the crystal ball: By Henry Kuttner

and other uncanny stories

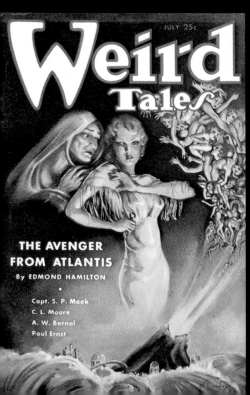

JULY 25¢

Weird Tales

THE AVENGER FROM ATLANTIS

By EDMOND HAMILTON

Capt. S. P. Meek
C. L. Moore
A. W. Bernal
Paul Ernst

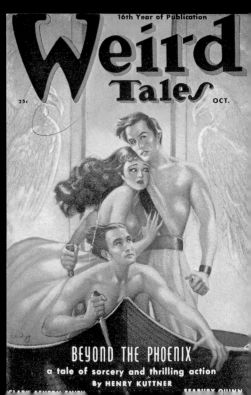

16th Year of Publication

Weird Tales

25c

OCT.

BEYOND THE PHOENIX

a tale of sorcery and thrilling action

By HENRY KUTTNER

Fantasy of popular culture

Wherever there is an audience artists perform their skills at weaving magic and fantasy. Comics, children's classics, adult fiction, theatre, movies, videos and record sleeves are all media which provide space for creating images from the imagination. The great fictional writers, past and present, have invented special worlds to which artists have responded by developing their own visual forms.

Preceding pages:
Weird Tales 1924-40
US popular magazine covers

Pulp magazines are an outlet for fantasy artists. The prose only hints at acts of violence, sexuality, submission and torture, performed at night, in jungle and dungeon. And the covers of *Weird Tales* and others reflect the content.

Comic sources
Pictures are the best way to capture children's attention so, before television, artists developed the comic strip to a high art. Today adults often find fantasy comics more attractive than children. From the creators of Batman, Superman, Rupert Bear, Barbar the Elephant and Tintin came new worlds. Here are three examples of great comic artists at work:
1 Frank Bellamy, an English illustrator of the 1960s, created space pilot Dan Dare.
2 Winsor McCay, illustrator of the New York Herald, created Little Nemo.
3 Wilhelm Busch, late 19th century German illustrator, created Max and Moritz.

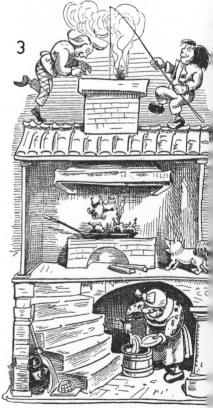

Children's fiction

Carroll, Anderson, Kipling and Potter and the lesser-known authors of Pinocchio, Goldilocks, Red Ridinghood and Mother Goose have created magic worlds.

1 *Gulliver's Travels*, offers giants, dwarfs and horses that talk.

Adult literature

The horror stories of Poe, Shelley, Lovecraft and Stoker or the fantasy of Burroughs, Conan Doyle, Wells, Verne and Tolkien all provide strange and bizarre images.

2 Mary Shelley's novel *Frankenstein* has spawned hundreds of pictures and portrayals on TV and film.

The theatre

Puppet shows, pantomimes, ballets, operas, plays and the circus all contain an element of fantasy.

3 The English pantomime, *Puss in Boots*, is a surreal tale of a cat that talks and walks on two legs.

Movies

Fantasy has become more sophisticated, from the 1902 films of George Melies to *Star Wars*, *Aliens* and *Planet of the Apes*. Tricks and animation have enabled artists to forget the laws of space, time, matter and logic.

4 *King Kong* is a classic example of make-believe. A giant gorilla is tamed by the beauty of a young girl.

Videos and record sleeves

New media provide fresh opportunities for the artist to exercise his imagination.

5 *Evil Dead*, the video, used new techniques to produce scenes of horror and nightmare reality.

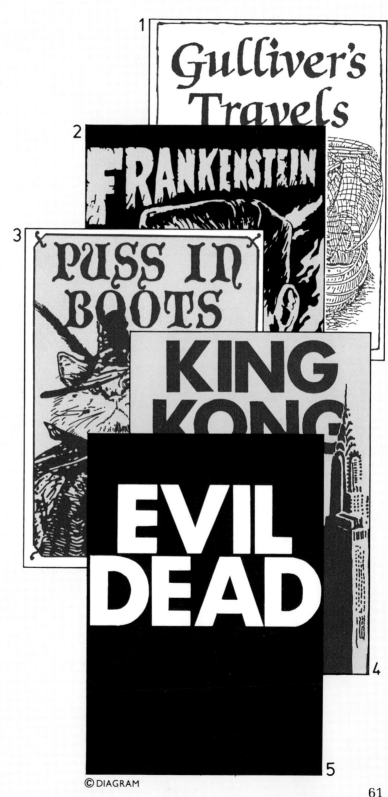

© DIAGRAM

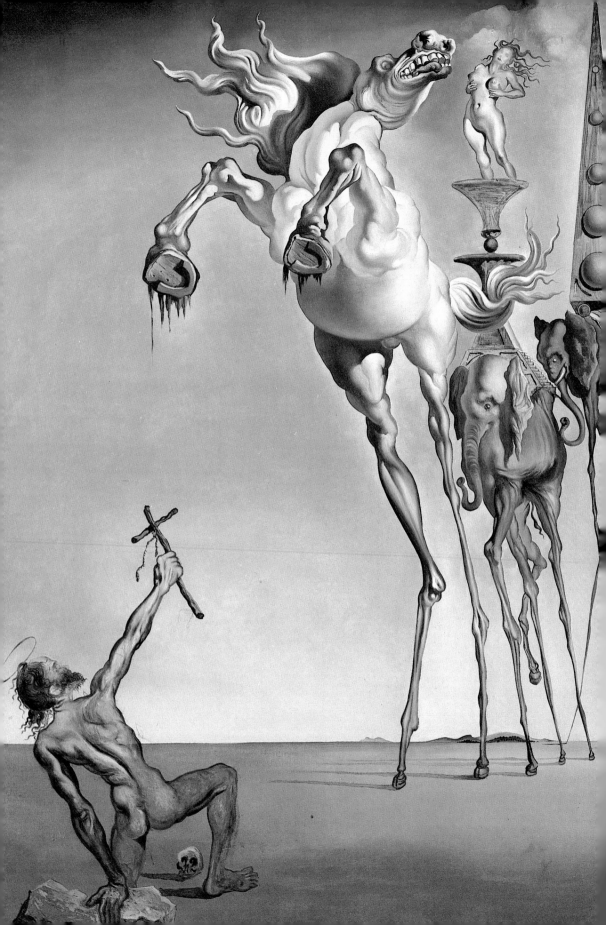

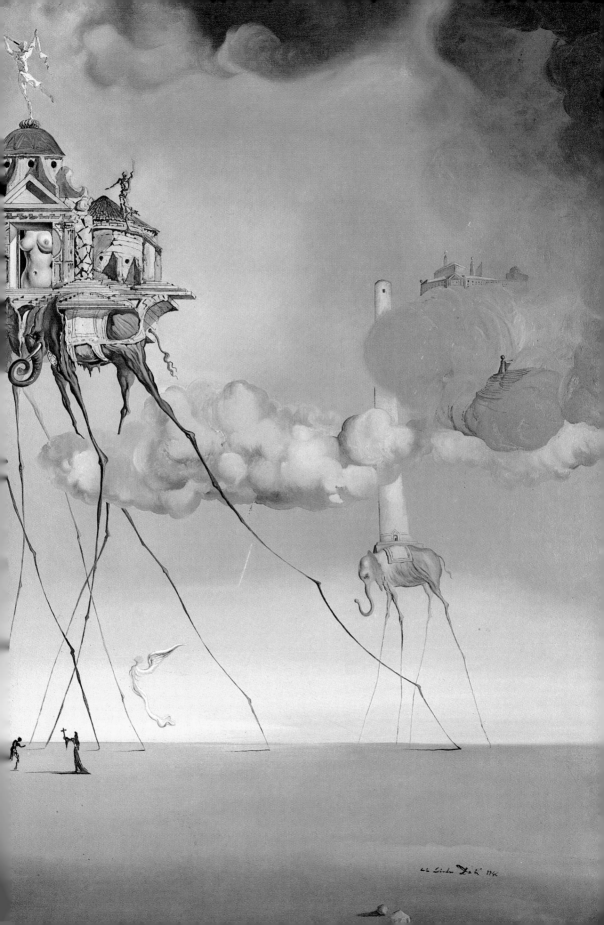

Fantasy of self-indulgence

Every individual has a fantasy world of his own, but only a very few ever depict it in pictures; that this kingdom be imagined or dreamed about and then forgotten seems to be sufficient. But 19th and 20th century artists have very frequently exploited this private realm as a storehouse of ideas which they have recorded, usually in great pictorial detail, and put on public display.

Because this art-form can emerge only from sources already digested in the subconscious, it invariably contains references to the artist's own experiences and observations. For it to succeed, it relies very much on shared private knowledge or jokes. The observer knows that the artist knows that he knows the references in the painting.

Preceding pages:
The temptation of St Anthony
Salvador Dali, 1946

A major advantage of all 20th century artists is their ability to gain access to visual sources from different times, cultures and materials. Photographic reproductions, television and movies have provided modern artists with resources beyond the wildest dreams of their forebears. This painting of *The temptation of St Anthony* is an example of an artist being 'clever'. Producing a picture which is intended for public or private galleries, a picture to display his skills and knowledge, he includes a reference to Bernini's Column in Rome and the Escorial Palace in Spain. The main purpose of such paintings is to startle and draw attention to the artist. Like naughty children such an artist must be mischievous to succeed.

Private fantasies
The painting (*below*), *The caress* by the Belgian artist Fernand Khnopff, was painted when he was 38 in 1896. Understanding of the picture is greatly enhanced by knowing that the female portrait is that of his sister, whom he loved passionately, but could not possess. This painting is an elaborate private joke.

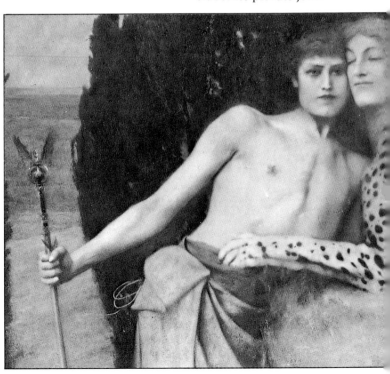

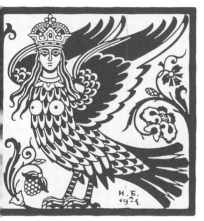

Frivolous fantasy
Many newspapers and magazines offer a ready supply of objects for private fantasy, either social or sexual. This is a means of achieving in imagination new levels of life not at present available by normal means; elevated shoes to increase your height, or plastic aprons (*right*) to change your sex. Almost all are unbelievable and none fulfill their promises.

Folk art fantasy
An illustration of an invitation to the private showing of the Russian artist Ivan Bilibin (*above*). The exhibition was held in Alexandria (Egypt) and the artist used the traditional techniques of Russian folk art to depict a sphinx-like figure.

Section Three
Developing ideas

Once you have an idea, how do you realize its potential?

This section explores some of the techniques for developing the image beyond its original form. Your picture may look normal, but you can insert an element of surprise – for example, by showing normal objects in an abnormal way – to create a fantasy image. The elements within your composition may be changing their appearance. Your picture may contain two images combined to make one, either superimposed or buried within each other, to create a double deception. The creatures you create can be the result of the combination of different animals, eg the griffin; anthropomorphic forms (animals with human attributes), eg Mickey Mouse; or creatures made up from inanimate materials, eg robots.

Compositional features or surface qualities may be altered, thus changing a picture quite radically. A distortion in the perspective, or turning the view upside down creates spatial tension and is another way of heightening the dream-like effect. The use of surface quality adaptation can open many new doors, leading to new ideas for subjects, and turn you back to look at previous examples of your work for the possibilities which may lie in them.

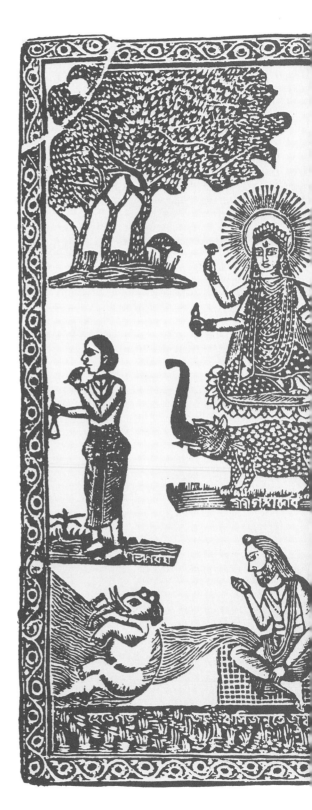

The 19th century Indian popular print (*right*) depicts gods in sculptures and relief carvings from Hindu temples. The artist has mixed these images with the theme of the life of the sacred River Ganges.

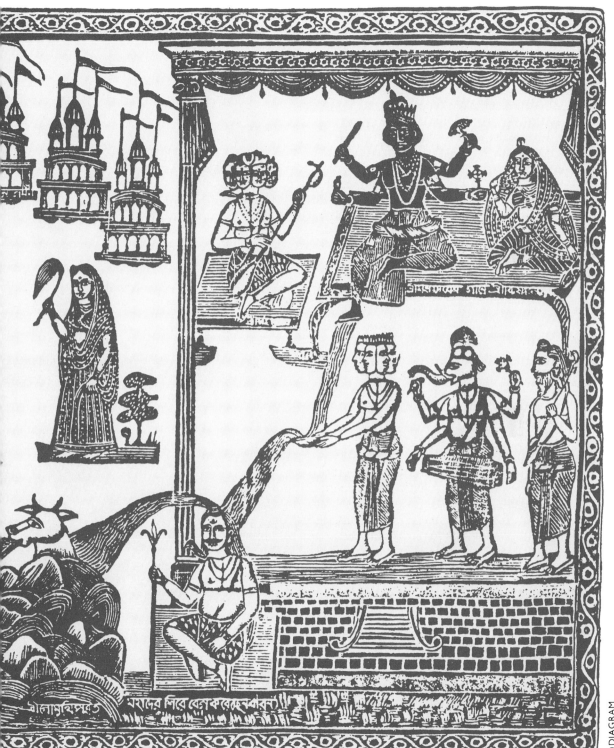

Elements of surprise

The simple and effective way to achieve fantasy in an image is by the subtle presence of an unusual element. A way to do this is to add features that fit completely into the general appearance, but on examination prove unlikely or impossible. These intrusive parts create a disturbing feature which can unnerve our first responses to the image.

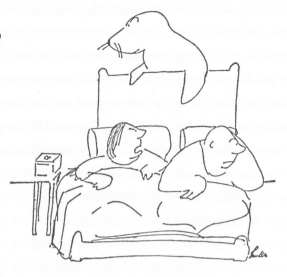

Irrationalities
Either the figure (*below*) is a man dressed in women's clothing or a woman who has grown a beard. The inconceivable is invariably disturbing. To contemplate a bearded woman could be more disturbing than a man in woman's clothes.

Improbabilities
"Alright, have it your way – you heard a seal bark!" The cartoon (*above right*) by the American humorist James Thurber, beautifully describes the unlikely being taken as the inevitable.

Impossibilities
The tower (*right*) is drawn using the normal laws of illustration. It appears at first glance to be a staircase on the top of a terrace, but upon examination its construction would be impossible. Surrealist painters often used this technique to build an image which looks normal but which in reality could not exist.

Incongruities
Showing normality with abnormal elements can produce simple images which cause a slight surprise. The reader does a 'double take'. The three illustrations (*right*) show how easily we first think the image is normal, only to discover upon examination that each one has something unusual about it.

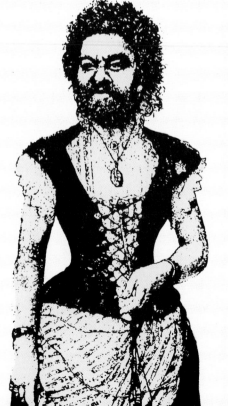

Creating incongruity

When combining images, their joint effect is best described as 'the sum is greater than the parts'. The property of subjects when combined creates a mix which exceeds the effect of the basic ingredients. Scale, textures, substance, events, space, when mixed irrationally can create disturbing combinations.

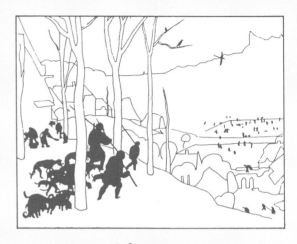

Substance

Shoes are made to protect our feet so a shoe with toes (*left*) is a contradiction. Pencils are hard, inflexible objects so a pencil tied in a knot seems impossible. Our prior knowledge of the character of an object means we find it difficult to accept objects having properties different from those we have experienced.

Scale

Three monkeys (*right*) examining a kissing couple. Are they giants? Is the central image a T.V. screen, a window, or a painting? Without additional information the image is an enigma. The viewer is seeking a plausible explanation for the incongruous.

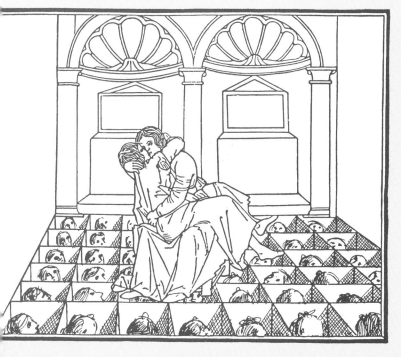

Pre-knowledge (*above*)
The painting by Peter Brueghel the Elder of hunters setting out on a walk appears in many books on the history of art. This copy by a modern artist omits the figures. The picture is disturbing only to those who remember the hunters' original positions (*opposite*).

Irrationality
The 17th century illustration (*left*) of a kissing couple is, in its original form (*far left*), already an image which provokes the question of who and why? By adding the cubicled heads watching the couple a modern artist has highlighted this feeling of enigma.

71

Using the size

Our experience of life leads us to assume the size of objects or creatures. A bear or a bee have a generally imagined size. Fantasy artists use this feature to disturb our views of the normal, placing objects alongside one another with disregard for their actual, related sizes. Our imaginations are stretched by being confronted with the visually impossible.

Comparative sizes
Human beings are often used as an indicator of scale. The groups of figures (*below*) through their contexts are, in one case, made to appear as giants and in the other as normal figures dwarfed by an enormous idol.

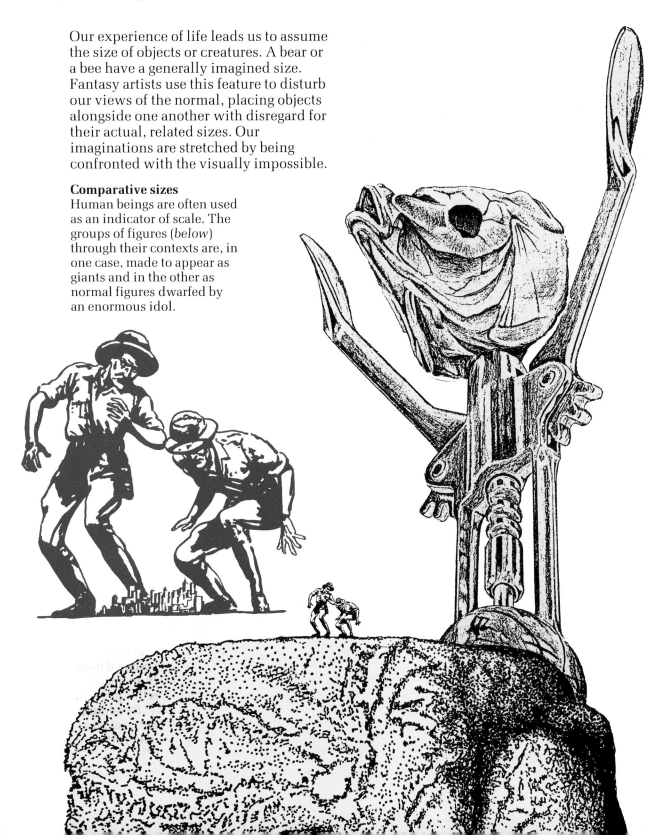

Perceived sizes

The composition (*left*) was produced from studies of objects found in a normal kitchen. The drawings (reproduced on page 16) were then re-arranged to create a towering idol. The loaf of bread became a cliff, the bottle-opener a mechanical device for working the idol's arms, and the fish head as the cold unsympathetic totem.

Context

The illustrations by the French artist Gustave Doré to the fantastic stories of adventures of the Baron Von Münchhausen, achieve their effect by the use of normal figures or locations in abnormal situations. The horseman (*right*) riding along the sea bed and being confronted by gigantic fishes is an example of the improbable set in the impossible.

Montage

Fantasy artists have delighted in using the technique of montage, the sticking together of two images cut from different contexts. This giant insect (*below*) is from a 17th century entomological book and the struggling hero from a 19th century source.

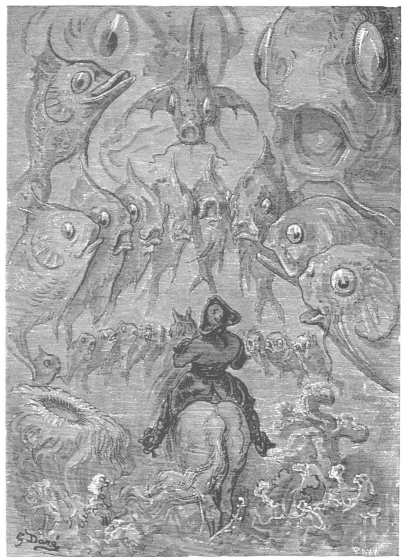

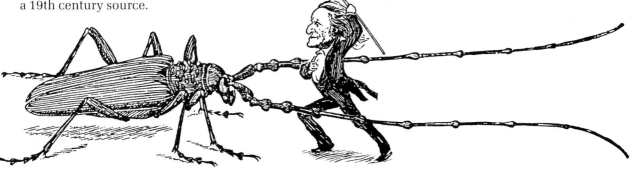

Combining images

Very often the artist can use normal objects and, by their strange arrangement and relationship with other objects, create new worlds of fantasy. To achieve the best results you must constantly collect images which spark off a tiny idea and store them for later use.

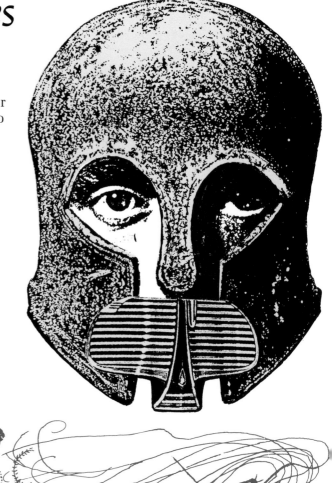

Warrior
The illustration (*right*) was made from three sources. A detailed drawing of a 5th century Greek helmet, a photograph of a face in a women's magazine, and a cut out photo from a 1940s car magazine of a radiator were combined.

Combat (*right*)
The struggling girl is copied from a ladies' keep-fit book, and her contestant is the larva of a grasshopper, greatly enlarged, stood on spider's legs and given wire tendrils.

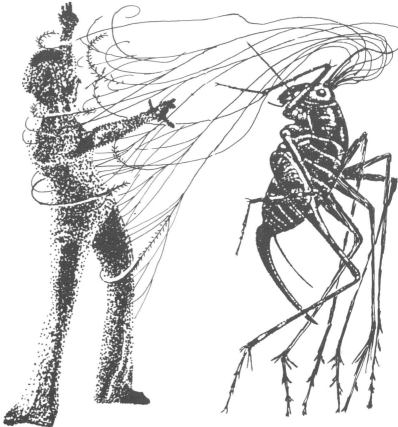

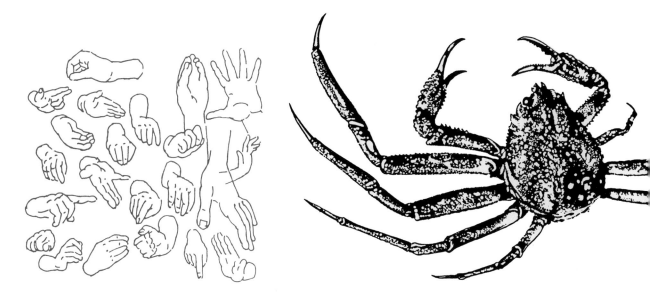

Victims

The purpose of this picture (*right*) was to describe the nightmare idea that we are all victims needing help from a source we cannot see or understand. The wall was drawn from a photograph, turned upside down, of the floor of an iron foundry. The hands were created from the study (*above*) of the artist's own hands. The attentive jailer was created from a study of museum illustrations of Pacific crustaceans. Images of this nature stir our imagination because they provoke the questions "Who is behind the screen? What are they doing? How do they exist together and what is the strange shell creature doing?"

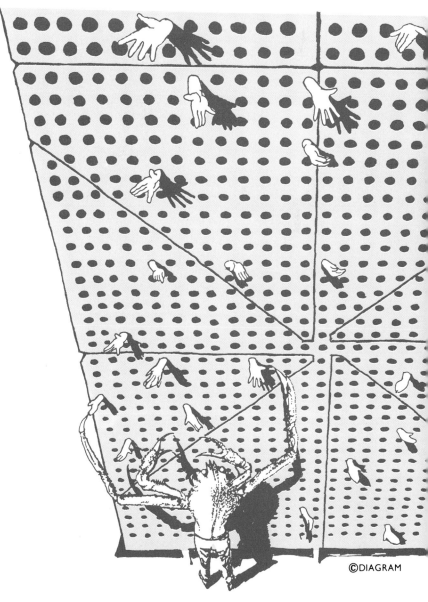

©DIAGRAM

Using change

The great exponent of changing forms was the 19th century scientist Charles Darwin. The idea that we could begin as one species and develop into another was a startling proposal to people who believed in eternal forms. Nevertheless, metamorphosis (the changing form), has always existed. Caterpillars change to butterflies, eggs to birds, seeds to trees. Nothing is constant.

Man to bird
A contemporary cartoon (*right*) ridiculing Darwin's ideas on evolution.

Man to monster (*opposite*)
Readers in the 19th century were particularly fond of stories involving human changes of form. This is an illustration to the Gothic novel by Stevenson of the *Strange Case of Dr. Jekyll and Mr. Hyde*. The effectiveness of these stories depends on the assumption that goodness has one face and evil another.

Teapot to scorpion (*below*)
Hallucinogenic drugs, fatigue and mental instabilities can produce effects where the normal appears abnormal. Reality changes with our perceptions of it. Successful metamorphosis depends upon the unlikely transformation of one object into another.

Seeing possibilities
The seven objects (*right*) were collected from illustrations in popular magazines. Try to imagine other forms which could be developed from these.

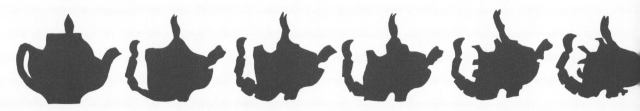

©DIAGRAM

Double deceptions

Fantasy artists often play with the readers' perceptions of the image. A visual game of 'look for the picture within the picture' is being played. Discovering whether we all draw the same conclusions about a picture can lead to interesting enquiries as to the very nature of perception. In children's comics and popular newspapers this theme has developed into a variety of puzzle games.

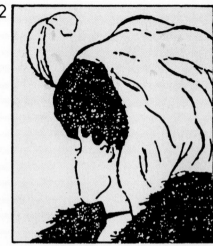

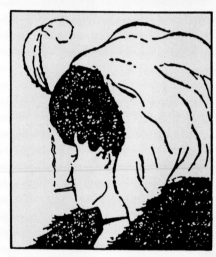

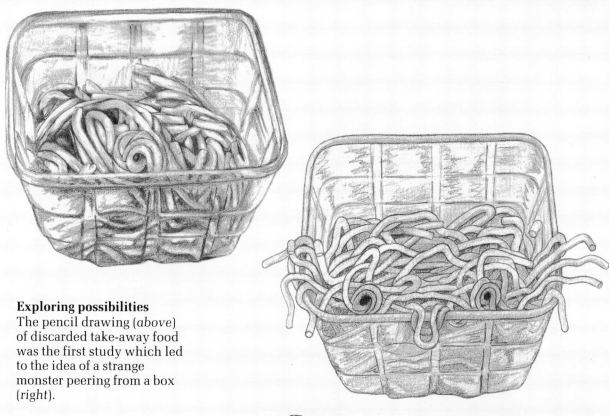

Exploring possibilities

The pencil drawing (*above*) of discarded take-away food was the first study which led to the idea of a strange monster peering from a box (*right*).

Double-take pictures

Sometimes we are caught unawares by visual tricks.
1 This could be a giant head or a rocky landscape.
2 The top illustration could be a young girl or an old lady. The subsequent two illustrations have added detail to clarify each interpretation.
3 This can be a black-faced doll, or by turning the page upside down, an old smiling granny.
4 Is this two confronting faces, or a vase containing a leafy plant?

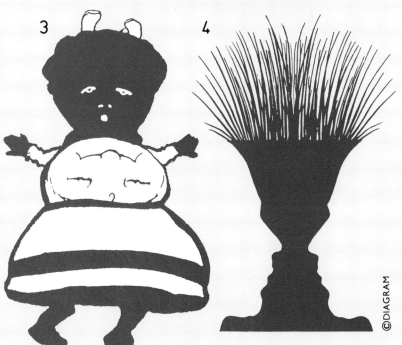

©DIAGRAM

Distorting your pictures

The next four pages have examples of methods of distorting an original image to explore the effects the newly-created image has on the value of the picture. The only really satisfactory way to achieve new results is by experimentation and by trying to think of unique ways the images you have can be developed.

Graphic techniques
The tools and techniques of the fantasy artist can be explored to create more powerful images.
1 An original image with a full range of tones.
2 The image described as lines traced along the edges of the dark and light areas.
3 The image drawn as only pure blacks or whites with no intermediate tonal values.
4 A negative version where the dark areas are white and the light areas dark.
5 This is illustration no. 3 distorted by photocopying it without placing it directly onto the photocopier's glass plate.

Double visual (right)
By carefully disguising the joints in the assembly of this image the hand appears to have seven fingers.

1

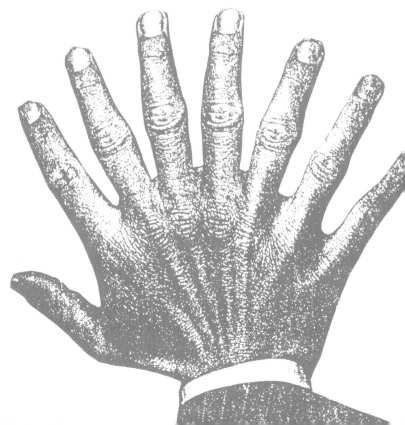

2

3

© DIAGRAM

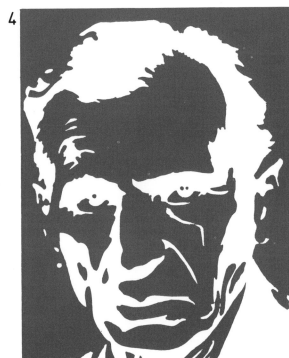

4

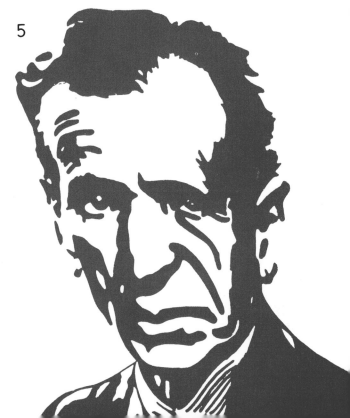

5

distorting your pictures

Two further methods of changing your images
A By the distortion of a superimposed grid.
B By mutilating and re-assembling the image or multiples of it.

Matrix distortions
The illustration is covered by a grid. You distort the image by re-plotting according to a grid where the axes move in one or more directions.
1 Extending the vertical.
2 and **3** Retaining the horizontal but distorting the vertical.
4 Extending the horizontal.

Montage distortion
5 Sliced and re-arranged.
6 Cut into circular strips and re-arranged.
7 Duplicated at a variety of sizes and super-imposed.
8 Montaged with negative elements.
9 Cut into strips and edited.
10 Super-imposed enlargements.

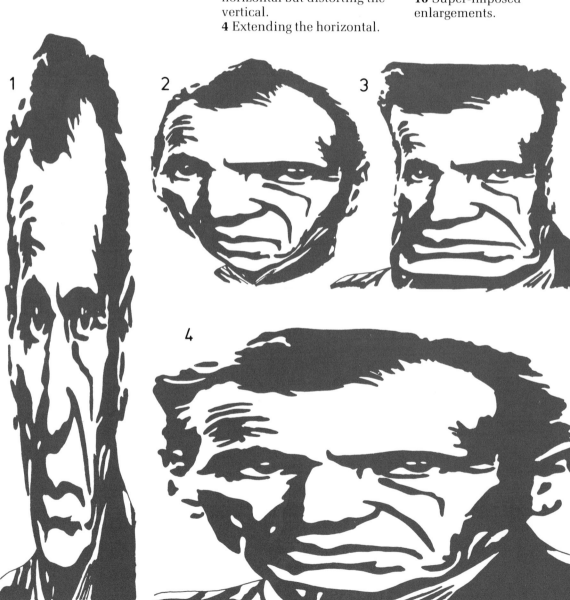

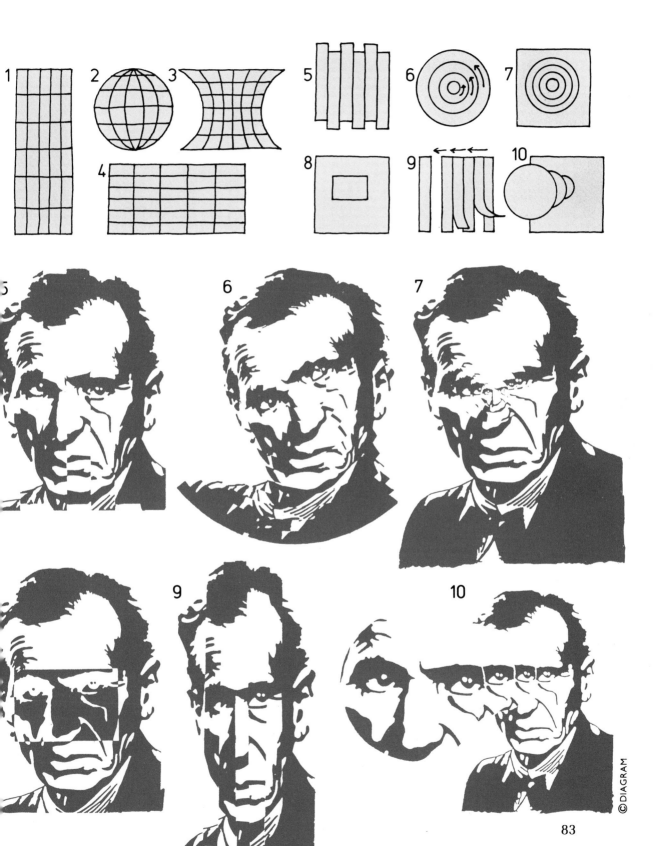

Superimposing pictures

One successful way to achieve fantasy pictures is by superimposing images. This is frequently done with the photographic technique of double exposure. Alternatively, two matching images can be successfully combined without a high degree of sophistication by the use of tracing paper overlays.

Exploring the head
1 Michael's pencil study self-portrait is made menacing by the addition of a snarling lion copied from a nature magazine and the surprised creatures protruding from his ears.
2 The ghoulish face produced by Mark was achieved by a self-portrait study superimposed over a tracing study of a skull.
3 In this 17th century portrait of a nobleman the artist wished to make a statement about the subject's character via the superimposition of the upside down portrait. Turn the book upside down to see the second face.
4 A very popular 19th century motif was to have images which appear to be one subject, but contain another. In this postcard we can find death.

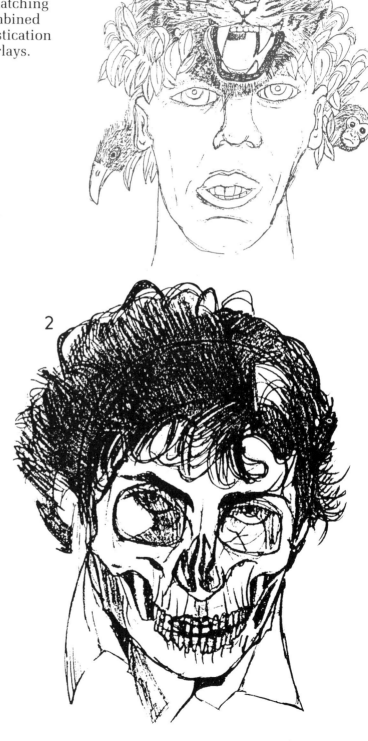

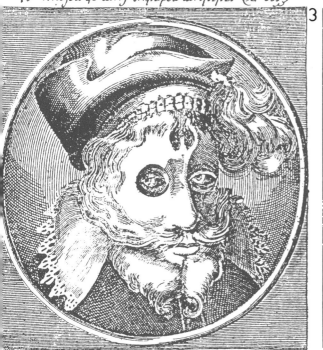

Ecce ad nihilum redditus sum et nesciui Psal 72
Quam miser et miserabilis Pauper cœcus et nudus

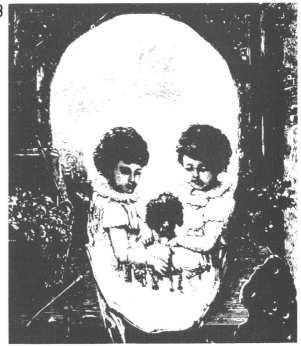

Non Sum sicut Cæteri. homines. Luc 18.
Diues sum et locupletatus et nullius egeo
Apo 3

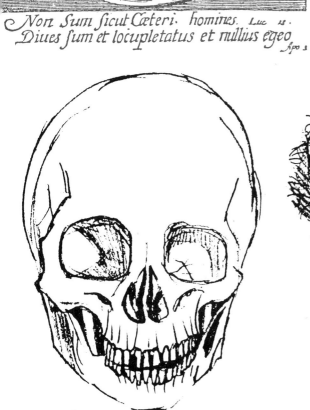

Human monsters

Mythology has been the breeding-ground for many half-human monsters. The synthesis of creatures and human forms has been used to imply that the hybrid contains some of the characteristics of the combined creatures' appearance. By adding parts of creatures thought to be repellent, eg claws and scales, the frequently unpleasant nature of the mythological creature could be more easily described.

Classical and ancient hybrids

1 A Harpy, with eagle's talons.
2 Medusa, with her head of snakes.
3 The Sphinx, with cat-like body and contemplative smile.

4 An Egyptian god, with a ram's head on a lion's body.
5 A Satyr, with goat-like legs and horns.
6 A Centaur, combining the bodies of a man and a horse.

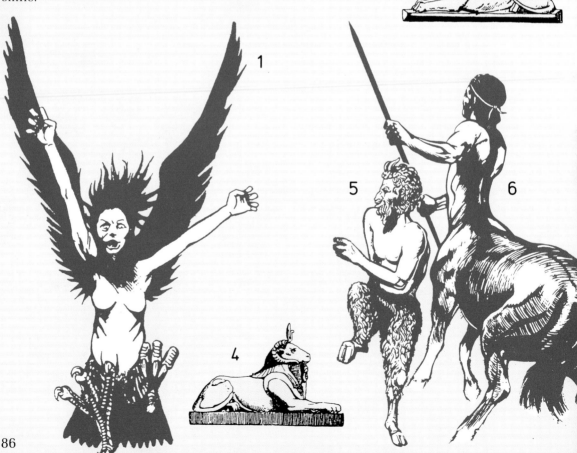

Exploratory groups
The five drawings (*above*) are a student's studies for developing an image of a half-naked female figure on the bodies of a variety of creatures.

Folklore sources (*below*)
Strange stories of unlikely creatures flooded the literature of early explorers and navigators.
1 A 19th century skeleton of a 'human fish', the work of a skillful taxidermist.
2 Mermaids and mermen decorated many early maps.

Personality portrayals
The 19th century postcard (*below*) grafts a female face onto a cat's body to hint at feline characteristics.

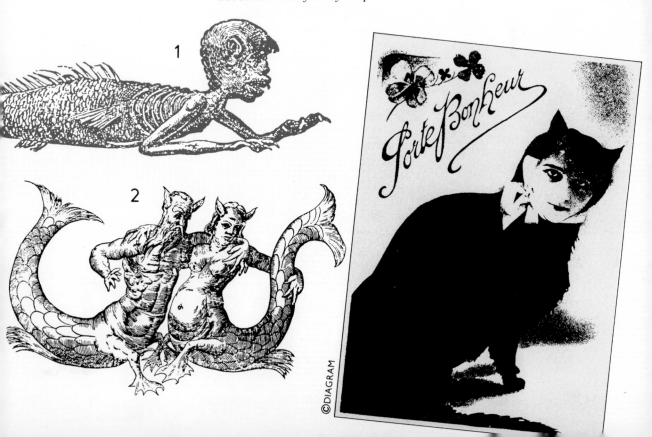

1

2

©DIAGRAM

Animals as people

Attributing human characteristics to animals has been a long tradition among fantasy artists. The fictional animal world of popular children's literature abounds with human-style walking and talking animals. Bears blow their noses on spotted handkerchiefs, dogs quote Socrates, elephants go to the barber's shop and foxes eat their supper using knives and forks.

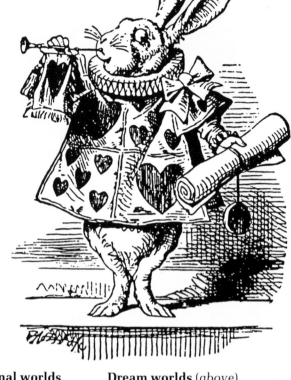

Representational worlds
This device (*left*) represents a mythological demon dog. It was used to decorate a doorknob in Renaissance Italy.

Dream worlds (*above*)
The 19th century author Lewis Carroll created a dream world for his heroine Alice. Here, among rabbits, walruses and frogs, human properties were attributed to animals so that they could converse with Alice.

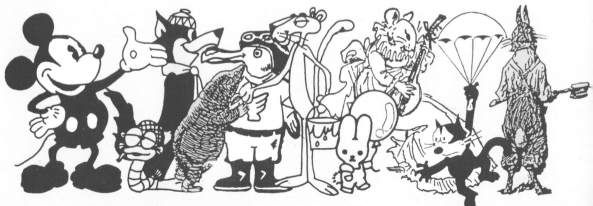

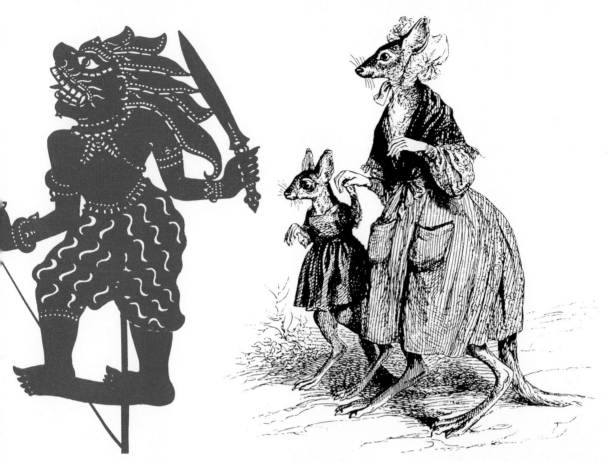

Allegorical worlds (*above*)
The shadow puppets of
Malaya include animals who
talk and walk as humans.
These fantasy figures are
interchangeable with gods,
spirits, servants, animals,
warriors and villains. Each
figure represents ideas and
morals.

Children's worlds
Movies, TV, comics and
popular stories abound with
animal creatures. How many
can you name in this
collection (*below*)? Do you
know where they appear in
children's entertainments
and what other famous ones
have been omitted?

Satirical worlds (*above*)
The 19th century illustrator
Granville depicted animals
performing human
activities. He used this
technique primarily so that
he could expose the follies of
contemporary society.

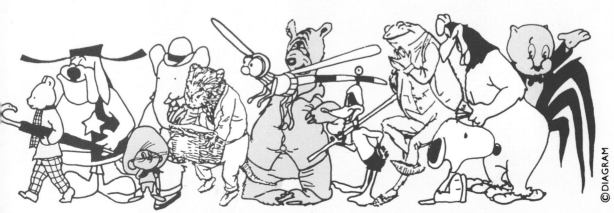

Machines as people

The inanimate object can be made animate by the imagination of the fantasy artist. Fruit becomes a face, metal a limb, furniture a body and, in the solid world of sculpture, iron or marble become human flesh. In the imagination of fantasy artists all materials can be given life. The artists play God persuading us to believe in their creations.

Substituted flesh
The painting (*below left*) is by an 18th century artist. Fish, fruit and plants were incorporated in such compositions more as a display of the skills of the artist than as a serious piece of fantasy art.

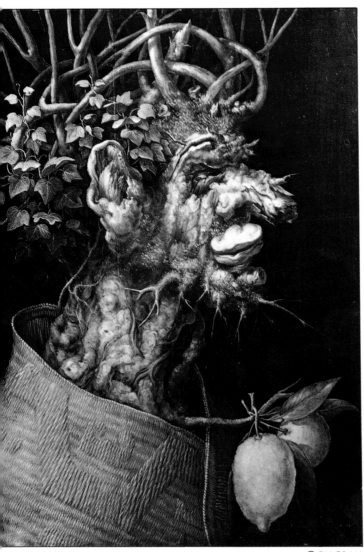

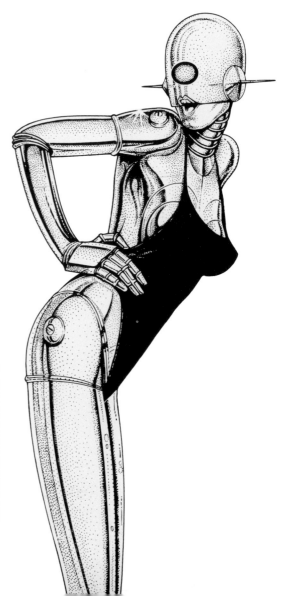

© DIAGRAM

90

Manufactured flesh
The depiction of robots, usually machines in human form, have been the strong interest of 20th century fantasy artists. Advances in technology have had a considerable influence upon artists' visions of the perfect robotic figure (*below left*).

Collected flesh
The assembled parts of manmade objects have been grouped in this drawing (*below left*) to represent a goldsmith. These 18th century illustrations were mocking the craftsman.

Constructed flesh
The drawing (*below*) is not of an imaginary giant, covered in ant-like humans. It is a picture representing the construction of the Statue of Liberty in New York. Sculptors use inanimate substances to describe animate forms.

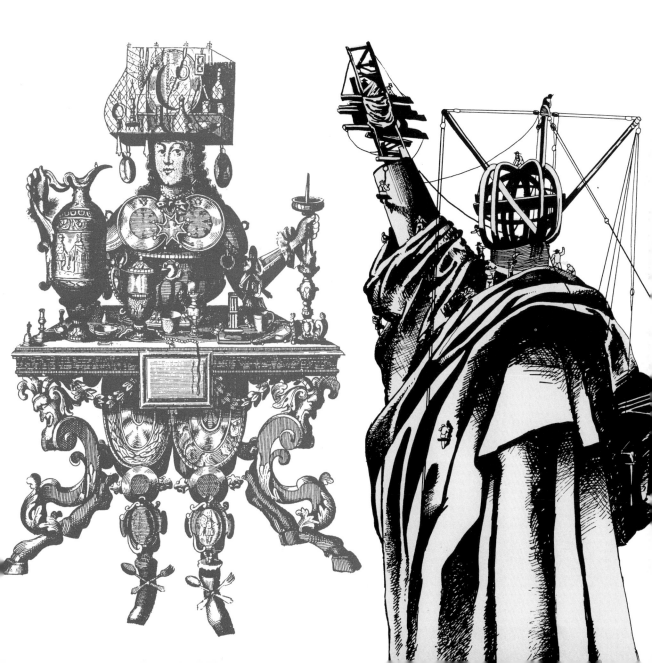

Your point of view

To achieve drama in a fantasy art
composition the artist can use visual
distortions of the elements, extremes of
lighting, dramatic scale variations, and
unusual or disturbing positioning of the
focus of attention. These tricks are
particularly exploited in the production
of comic book art, where the repeated
use of the comic strip as a vehicle for
images and text can be monotonous.

1

2

Viewpoint

Artists often select a viewpoint from which the elements draw us into the picture (**1** and **2**). Drawings need not conform to the actual laws of optical perspective (**3**). Some elements can be enlarged dramatically.

Composition

Note the use of dark and light areas (**4**) to direct the readers' attention. The cutting away of the edges of subjects (**5**) or selecting dramatic positions (**6**) adds emphasis.

5

3

4

6

© DIAGRAM

Deliberate accidents

An accidental occurrence in the production of a drawing may not always be detrimental. Accidental marks on a drawing's surface may enhance it and inspire new ideas. Many artists experiment with textures and keep examples of random discoveries. When you are not working directly on a finished drawing practise experimenting with new media, unfamiliar tools and surfaces so as to master the effects and use them confidently. Remember to be open to the unexpected.

Unexpected sources
A popular 19th century hobby was autograph collecting, and this led to the publication of a book entitled *Ghosts of my friends*. The book contained blank pages on which friends of the owner wrote their names in ink along a vertical crease. The page was folded over so that the ink smudged, producing a double blot or 'ghost'. The 'ghost' (*right*) is of the signature of Florence M. Woon, a dry version of which is printed (*left*).

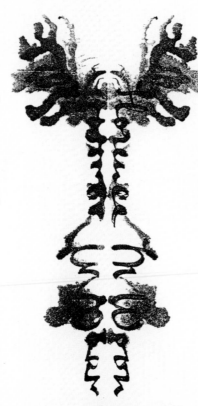

Surface accidents
The watercolour painting (*right*) is by Victor Hugo, the French 19th century novelist. While out sketching he often rubbed substances such as cofffee grounds and cigar ash into the surface. He also used a type of pencil which produced soluble marks to deepen and dramatize the tonal effect. However these techniques should be used with caution as they can destroy the surface of your work.

Shape accidents
The 18th century artist Alexander Cozens developed an idea based on making landscapes from inkblots. He thought that natural accidents resembled nature and inspired visions of imaginary places. The picture (*right*) was produced by dabbing a cloth dampened with ink onto a flat piece of paper. This was then placed, inked side down, onto another piece of paper which had previously been crumpled up. He gave the resulting pattern of inkblots to his students to use under a piece of translucent paper to produce fantasy landscapes.

The kaleidoscope effect
Multiple versions of an image can be made striking by producing them from a cut-out of a folded sheet. The pattern (*right*) began as a single figure and emerged as a dancing circle of figures. This method generates multiple images which it would otherwise be hard to invent.

95

Section Four
Techniques and tips

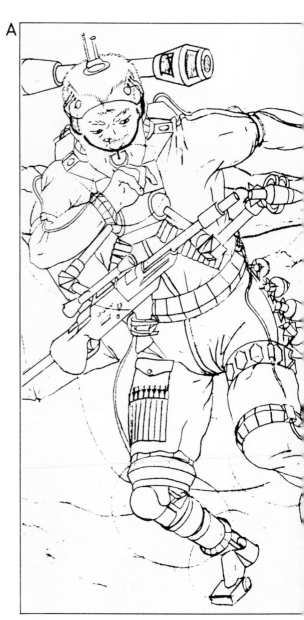

This section begins with a selection of eight pictures, each created by a contemporary fantasy artist, and each picture is an example of the way in which the artist has mastered his chosen medium. You too must constantly practice with the medium you find most convenient, and from which you obtain the best results. However, do continue to explore new media when not working on your finished paintings.

Always try to keep your work surfaces clean and your tools in good working order. Never buy cheap brushes, pens or paper. An initially high expense can prove a worthwhile investment and help you to avoid frustrations incurred when using cheaper, less reliable, tools.

Always resolve as much as possible either on independent sketches or studies, or by obtaining detailed references. Consequently, you should never have to arrive at a point during the painting when major elements are still unresolved and which could develop in a form you find unacceptable.

Study closely the surfaces of other artists' works to discover their method of working. Be careful when examining reproductions as these are often greatly reduced versions of the original and, as such, can imply working methods other than those used by the original artist. Try to see the work of fantasy artists in exhibitions or art galleries and, if possible, visit the studios of artists whose works you admire.

Three studies, in pencil (**A**), crayon (**B**), and brush (**C**), for a science fiction illustration. The top three are slightly reduced from the original, whereas the bottom three are greatly reduced.

B

C

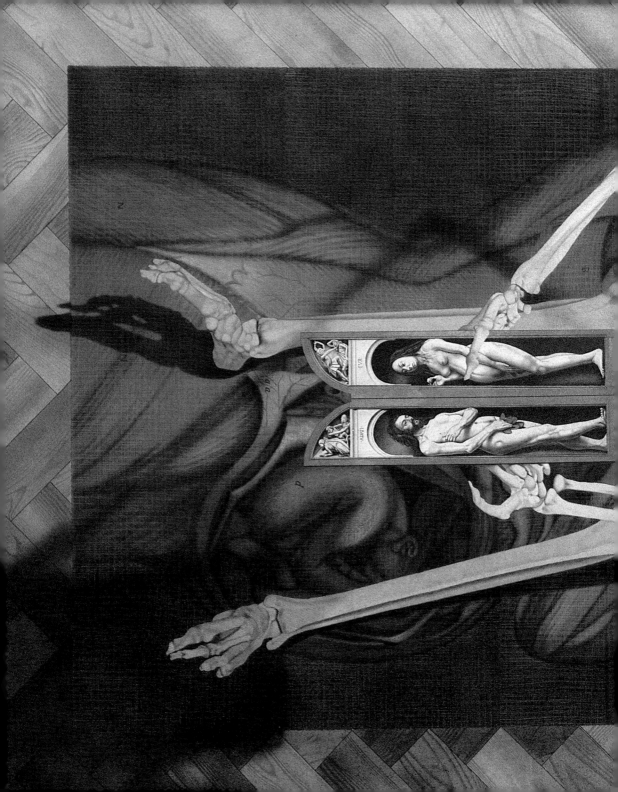

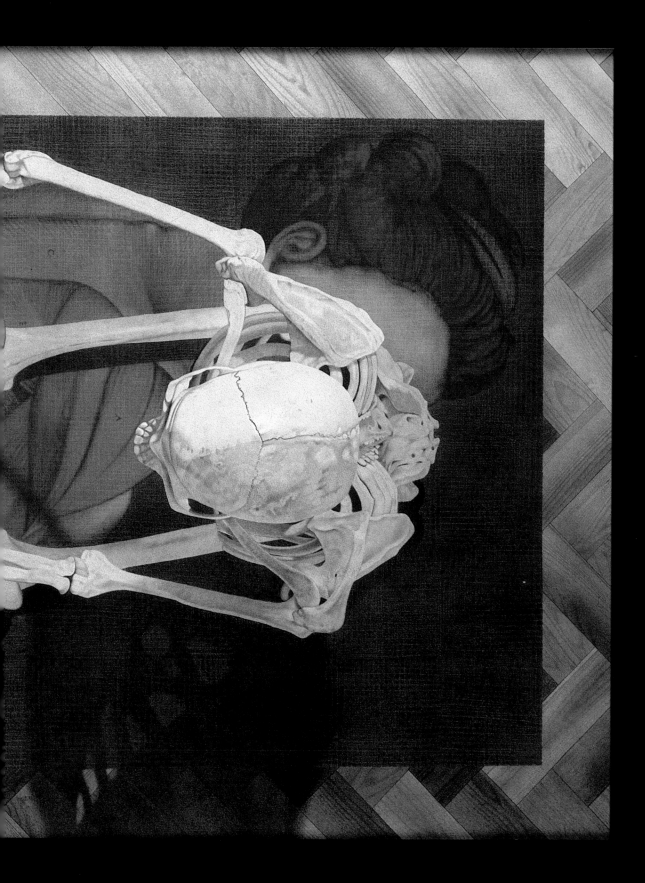

Pencils and chalks

Nick Cudworth
50″ x 30″ (127cm x 76cm)

Nick Cudworth works entirely with colored pencils, crayons and chalks. He achieves the clean effects by masking-off areas with paper cut-outs, while he works on exposed areas. His working method means that when all the areas are completed he must review the overall effects and carefully adjust those parts which did not merge with the adjacent areas.

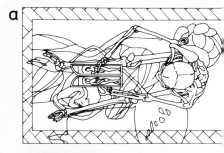

Elements used
● A full size human skeleton.
● An example of the work of Gauthier D'Agoty (an 18th century French illustrator).
● A black and white illustration by Jan Van Eyck depicting Adam and Eve.
● Parquet flooring.

The idea
Unlike most of the other examples reproduced in this section of the book, this one is not intended for reproduction. It is one in a series of studies of the skeleton which were framed and sold in an art gallery in the same way as a painting.

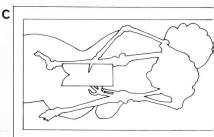

Research
The skeleton appears to be viewed from above, sitting on a carpet and holding an object. This view is achieved by fixing a full sized skeleton to the wall of the artist's studio. The pelvis is attached to the vertical surface so that the legs hang downwards, and the upper torso is suspended forwards on strings hung from the ceiling. (If you turn the previous pages sideways so the feet point downwards you will see this effect). A detailed study was then made of the subject on tracing paper to the final size of the drawing.

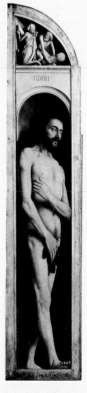
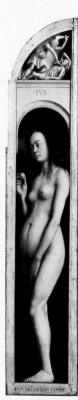
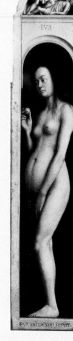

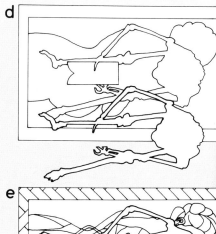

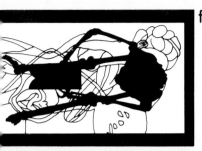

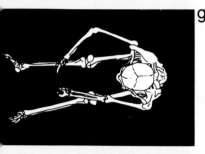

f

g

h

i

j

Planning

Nick traced the main details of the D'Agoty illustration. Using the technique of proportional squares he transferred the design onto the background of this master drawing of the skeleton. Around the central carpet theme he plotted a pattern of parquet floor tiles, using those in his home for reference. He then prepared a careful separate tracing of the Adam and Eve unit. These studies provided him with his master tracing (**a**).

Progressing the drawing

Nick used a technique of masking. Only selected areas were revealed. The others were protected from smudging by a protective cut-out of paper. He then applied a soft B pencil to the reverse side of his tracing (**b**) to enable him to transfer all the key lines onto a sheet of paper which he used as a mask (**c**). When this was complete he gummed the back surface of the masking sheet and, using a scalpel, he carefully cut out the skeleton from the design, and stored this shape for later use (**d**). To position the design on his intended surface he held down his master mask with paper weights then replaced the skeleton, pressing it onto the surface securely. The surrounding mask was then removed (with the exception of the central Van Eyck element). He replaced his master tracing and carefully recorded onto the drawing surface the details of the design (**e**).

Applying colors

Nick used finely ground powders of chalk, pastel-sticks and colored pencils. He built up his designs with soft, carefully fused values. He applied these on the design of the background carpet and constantly referred back to his original source references (**f**). When this was complete he replaced the mask, removed the mask of the skeleton, and then worked the details of the bones into the silhouette (**g**). Eventually, Nick removed the mask for the parquet floor tiles and colored them (**h**).

Shadow effect

Nick cut separate masks to reveal the shadow areas and reworked the shadows over the initial drawing (**i**). When the design was complete he began to rework all the areas, and particularly the edges of the masked surfaces using wax crayons, pastels and colored pencils to fuse the elements into one cohesive design. Finally he removed the central area of the small object held by the skeleton and completed the copy of the Van Eyck figures (**j**).

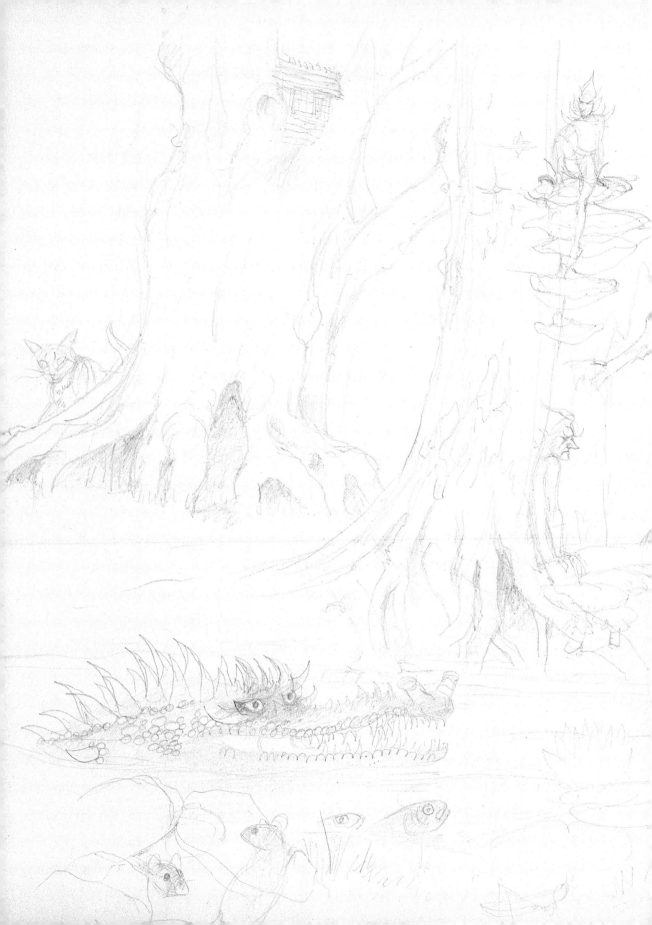

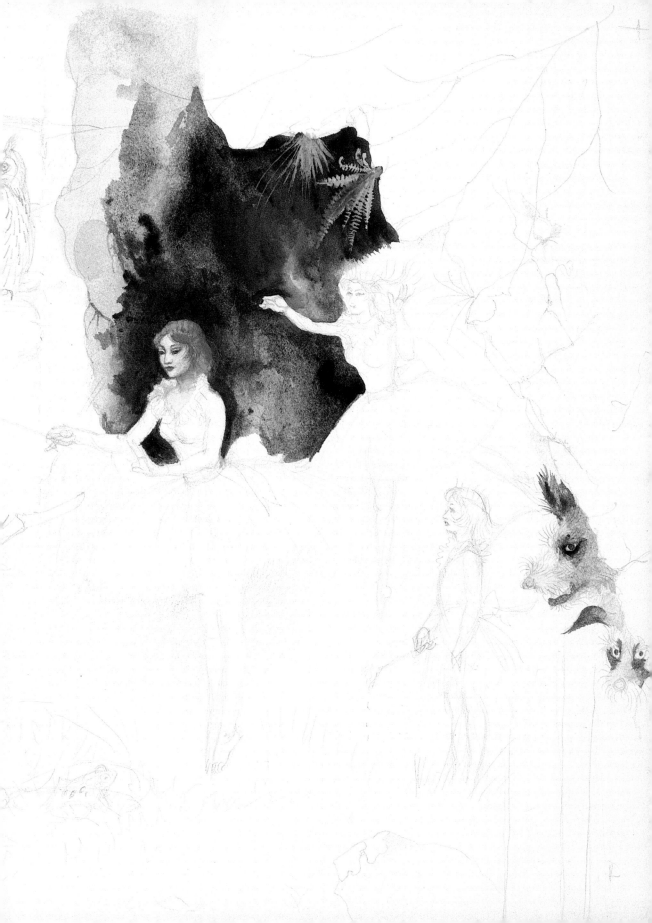

Pencils and watercolors

Maurice Wilson worked for over fifty years producing delicate studies of real and imaginary creatures and plants. He was renowned for his ability to portray creatures using very little reference material to aid the task, sometimes reconstructing long-dead creatures with only a few surviving bones as a guide. He worked mainly with water solvent inks, adding highlights in acrylic paints. After planning his pictures he usually began painting the dark areas, building up the main elements in watercolor and adding lighter areas with opaque pigments. The study on the previous two pages of fairies in a magic wood is in the early stages of painting. Unfortunately while producing this picture Maurice sadly died, aged seventy three years. This is his last, and as it is incomplete, his most revealing work. His huge knowledge of geological, geographical, botanical and anatomical detail made it possible for him to get a high degree of realism working from memory. Nevertheless he would frequently return to nature studies for some new aspect of reality and to maintain a freshness of vision. He believed that great care must be taken over truth to nature to endow the fantasy image with a high degree of realism.

Maurice Wilson
Illustration for a fairy tale, unpublished
17¾" x 11¾" (45cm x 30cm)

Nature study
The pencil study (*left*) is a reduction of a sketch, by Maurice, produced from a study of a tree in a wood. These observations reinforce knowledge and aid the development of accurate detail.

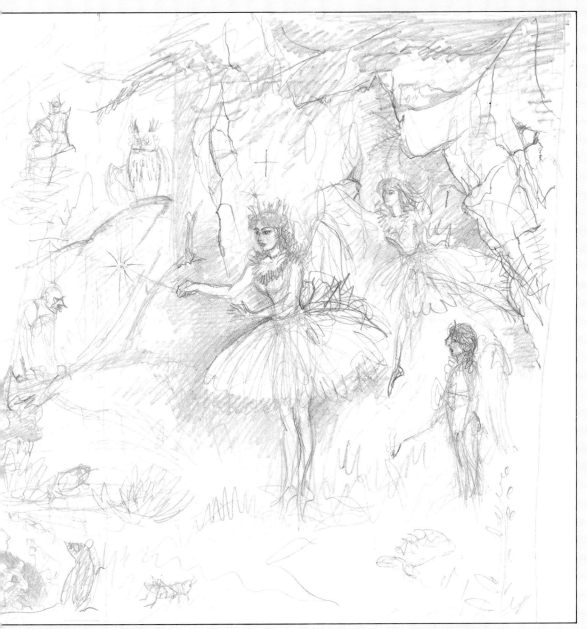

Preliminary sketches

The composition is worked out several times in generalized sketches (*above*). This is how the landscape evolved. Consequently, the final picture is an amalgamation of many of the ideas that have become fused in Maurice's memory.

Adding detail

Once the composition is resolved Maurice develops the tiniest details simply by imagining the surfaces he is painting. The mischievous fox-like creature (*right*) is the result of thousands of studies made of mammals from nature and photographs.

© DIAGRAM

105

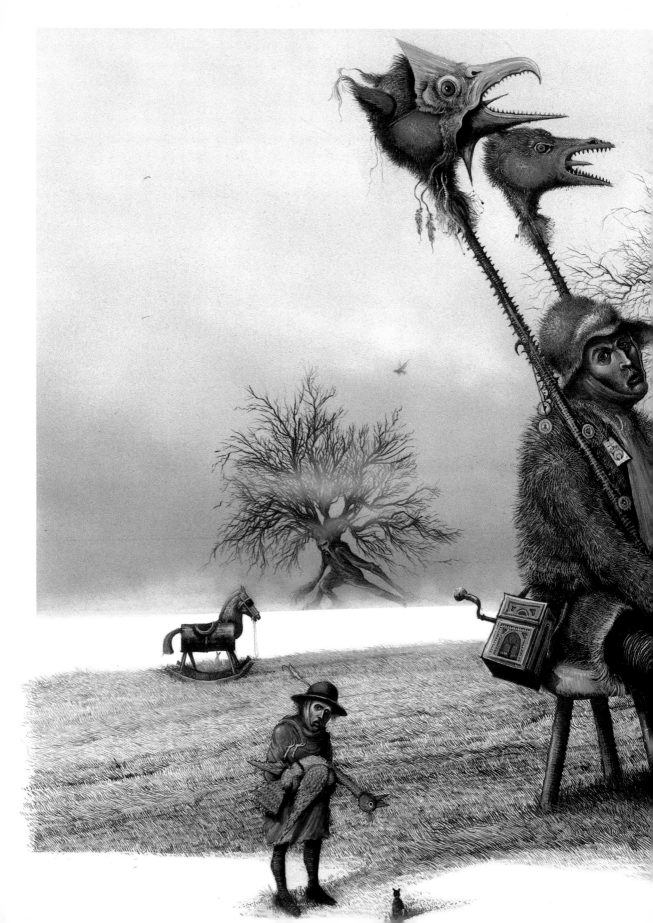

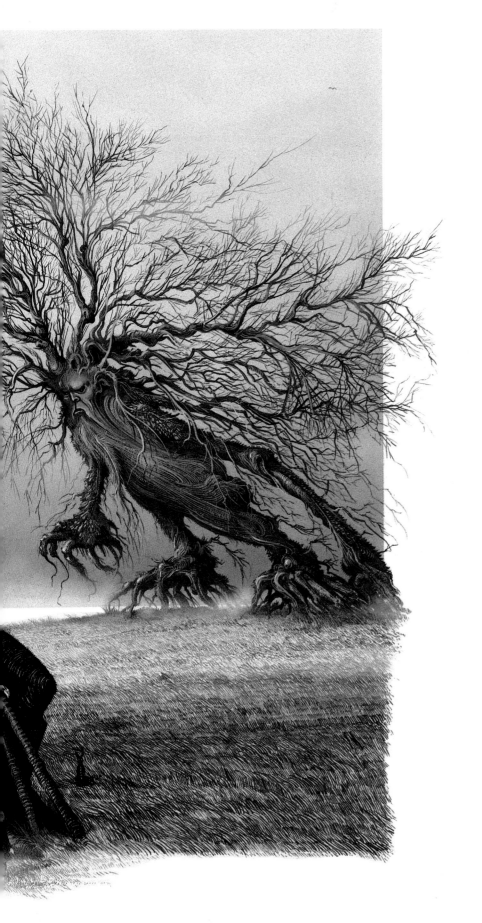

Inks and watercolors

Ian Miller
One of four paintings for
a calendar, unpublished
15″ x 12″ (38cm x 30cm)

Ian Miller trained as a fine artist and slowly developed from an oil painter to one who uses inks and watercolors extensively. Although his ideas have great freedom of expression, the detail within each picture is carefully resolved. His images come almost entirely from memory – they are stored details of the observed world which he can recall and build on. He seldom uses photographic or technical source references as he believes these can inhibit his exploration of the shapes and surfaces of the drawing. Having worked in Hollywood on film animation, he has developed some of the habits of animation artists who work on nonabsorbent surfaces. His work often has an element of the grotesque and the Gothic, which creates a sense of unease in the viewer.

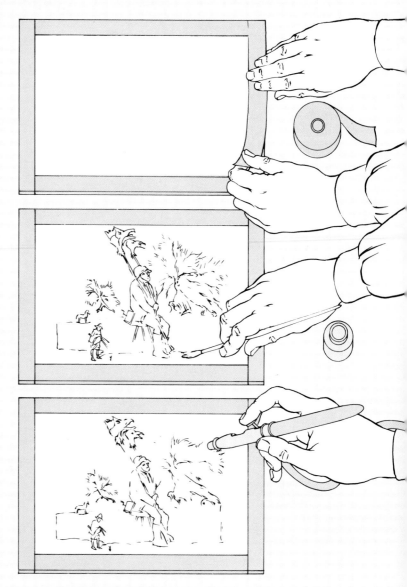

1 Ian dampened a sheet of hot press paper which has a very hard smooth surface. He then stuck it to a board using tape. It contracted as it dried, giving a firm, tight working surface.

2 Using a brush Ian applied a coat of masking fluid to the lower section of the composition. This allowed finer edge work than cut-out film or paper masks would have.

3 Airbrush backgrounds were produced with Ian's mix of watercolor and water solvent dyes. Their delicacy held the stronger elements of the drawing.

4 Ian applied a technique used in animation artwork and carefully dried the picture at each stage. He used an ordinary hairdryer to blow cold air onto the work.

5 Ian used a movable sheet with a cut-out hole (rather as a surgeon uses sheets) for working on each section. He wore fingerless gloves which avoid static and dust problems as well as keeping grease off the surface. He also used the gloved hand not holding the brush as a wiping surface for his brush.

6 When the individual sections were finished Ian removed the masks and tied together any discordant areas. Detail was strengthened with technical ink pens.

7 If you look closely at the left hand tree you will see that a fine mist has blown across it. This final breath of mystery was added when the drawing was complete. The final touches show the skill of a master craftsman.

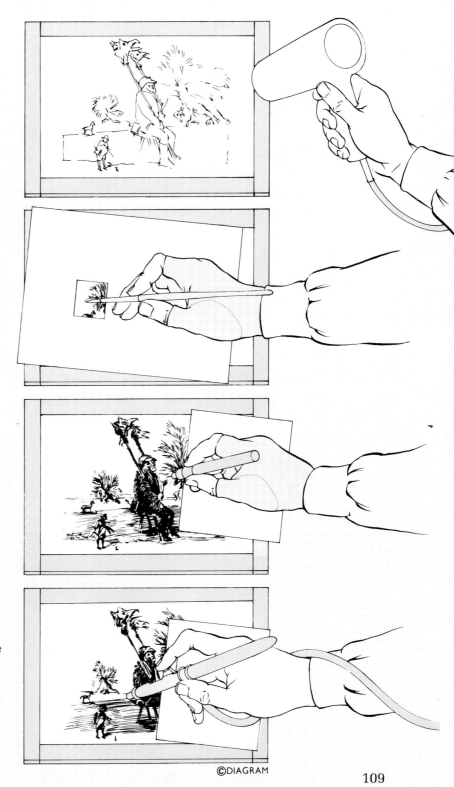

©DIAGRAM

109

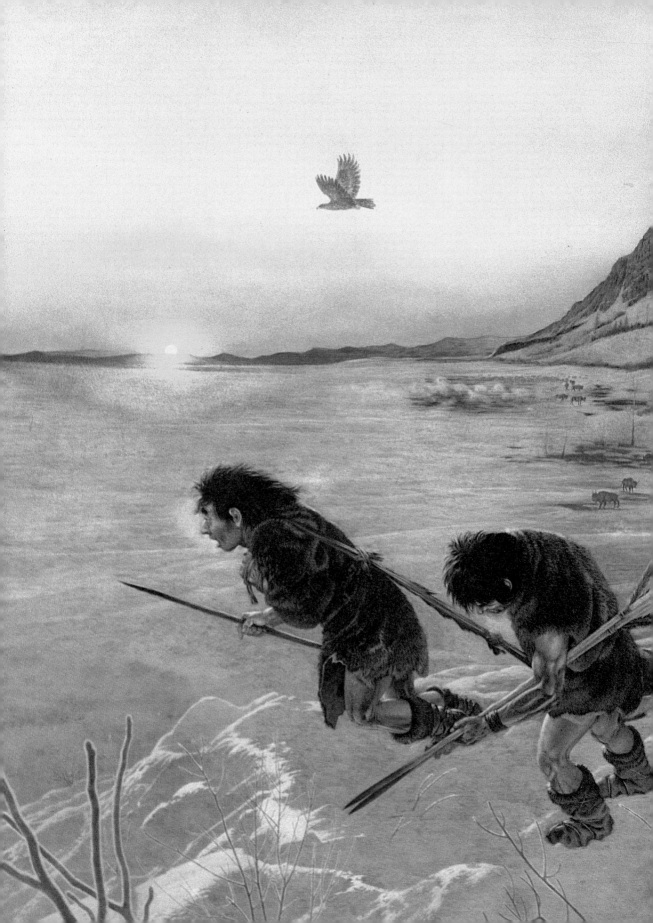

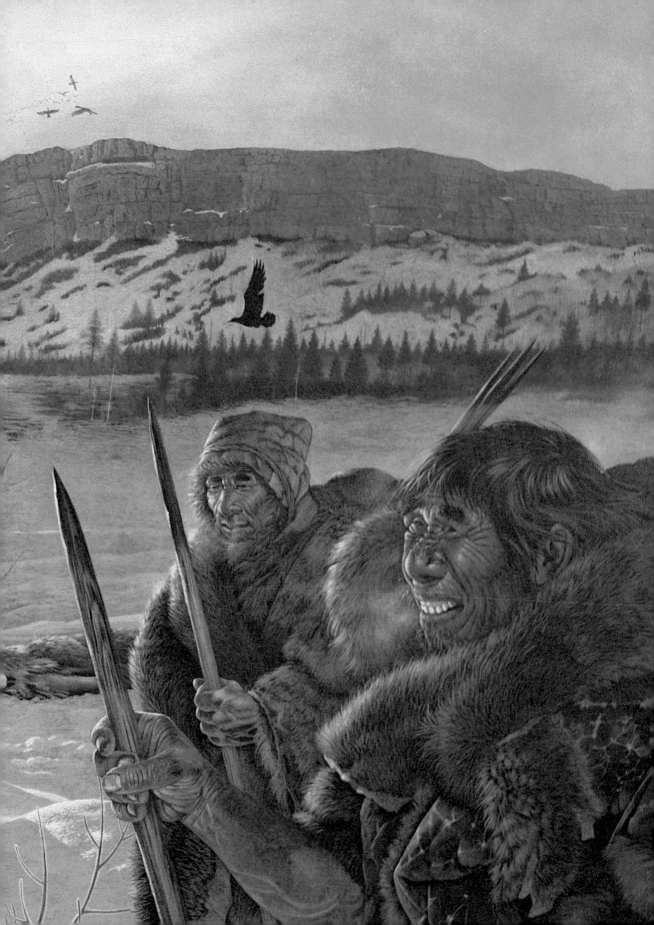

Gouache colors

Giovanni Caselli
Illustration for *The evolution of Early M*
published by Eurobook Ltd, UK
15¾ x 25½" (40cm x 65cm)

Giovanni Caselli is an acclaimed master of the creation of images of earlier civilisations. He produces pictures of worlds for which we do not have contemporary visual record in a form which meets present-day needs. His pictures are based upon an imaginative and sensitive understanding of the discoveries of archeologists and historians. He brings the past alive for the present-day reader of history. His imaginary pictures are the result of extensive research and constant updating of his archives of the smallest details of those past worlds. He successfully incorporates this reasearch into pictorial situations based upon modern landscapes which stand as a convincing framework for his reconstructions.

Present-day sources
Hills, birds, faces and figure shapes are all derived from photographic sources in magazines such as the National Geographic. From his collection of over a thousand color magazines Giovanni can find references which act as a visual archive of the smallest details in his landscapes.

The spear (*right*) is an object found in a grave of hunters of this period. There are no visual records of how the weapons really looked. Giovanni began his reconstructions of the hunters by studying archeological finds of the period. The skull (*below*) has a projecting but 'swept-back' face. Giovanni incorporated this information into an illustration of the head of a present-day eskimo.

The painting (*previous page*)
This illustration of Neanderthal hunters is a reconstruction of the life of homo sapiens 80,000 years ago. It shows how they may have looked returning from a successful killing during the time when Europe was extensively covered with a semi-permanent layer of ice.

Contemporary sources of information
Early man used art to depict creatures and events central to his existence. The illustration (*below left*) is a Neanderthal man's representation of woolly mammoths. It was painted on the wall of a cave, and is one of the few surviving records of life at that time.

Materials

Normally Giovanni works on birch plywood panels which have been sized with a covering of gesso (similar to plaster of Paris). This provides a very smooth surface and a more permanent base than canvas, paper or card.

Size

Working for reproduction (pictures to be published), Giovanni painted his composition half as large again as the reproduction size. This made the detail sharper and crisper during reproduction.

Planning

Giovanni produced a pencil sketch of the composition so that he could build up all the elements required within one grouping. He used a soft lead pencil on tracing paper, and worked to the size of the final painting.

Tracing down

After working out all the major details, and possibly reserving particular areas independently on separate sheets, he transferred the composition to the board using a hard pencil. This left a fine groove in the surface which does not appear in reproductions, but which guided him during the painting of the picture.

Implementing

He began by painting in the three major areas. Foreground (**a**) in dark sepia, middle distance (**b**) in purplish brown, and sky (**c**) in ochre. He then copied the details from photographs or his own pencil reconstruction using gouache.

Development

This painting was progressed from dark base colors to light areas, each successive layer of detail being produced by an increasing thickness of pigment. Large areas were produced with thin washes of lighter colors, highlights and small dark details with thick gouache. The work was mostly produced with a variety of brushes, but areas such as the freezing breath (*detail left*) and the sunset were achieved using a fine foam sponge.

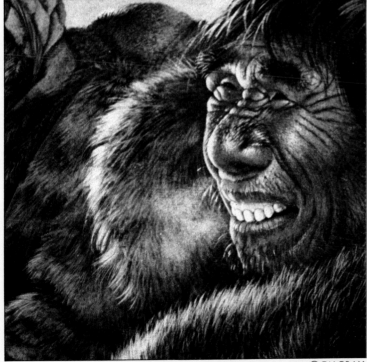

© DIAGRAM

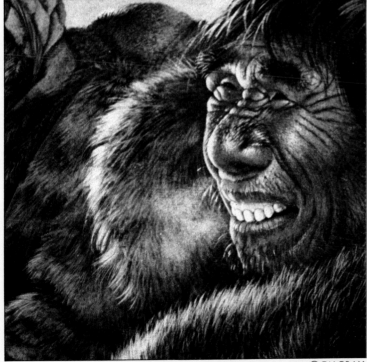

113

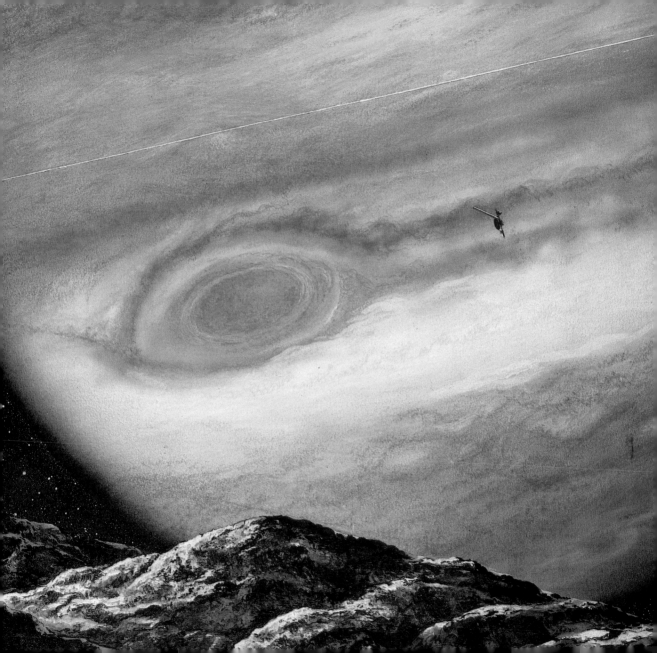

Gouache colors and pencils

Robert Chapman
Illustration for a science journal, unpublished
16½" x 8½" (42cm x 22cm)

Robert Chapman's technique is to work in water solvent colors, building up the details of his compositions from many references and sources. His extensive knowledge of astronomy ensures that the final paintings are true descriptions of up-to-date planetary features. His main skill is in using an airbrush to describe different surface qualities. He normally works in a larger format than the final, printed illustration.

1 Robert first worked out the basic composition on tracing paper, basing the elements upon references collected over many years. He then sketched in the framework of the composition in soft pencil onto artist's watercolor board.

2 The foreground and planet Jupiter were masked out and the sky sprayed a dark blue. When dry, an uneven application of soft patches of black was sprayed onto the blue to create an illusion of depth.

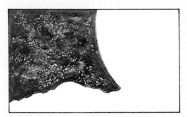

3 Robert then 'splatter sprayed' white dots onto the sky, which was finally lightly fixed with a spraying of gum to prevent damage during later work.

4 The mask over Jupiter was removed and the sky was masked out. Bright, light bands of color were handpainted onto the planet's surface and then overpainted with darker details. These bands were fused with patches of spraying to blend the tones together. The surface granulation was achieved by adding pencil over dry paintwork.

5 The mask over Callisto was removed and the major dark areas painted in, followed by lighter areas. All the paintwork was kept thick on the moon's surface to simulate a rough texture.

6 The mask on the sky was removed and the side view of Jupiter's bands painted in with brush rule technique. Finally, any tiny irregularities between each masking were removed, and the tiny space probe, Voyager III, added.

Splatter work (*right*)
Uneven splatter dots can be
achieved by removing the
nozzle of the airbrush and
shooting bursts of paint at
the surface. Great care must
be taken to avoid accidental
heavy clustering of splatter.
Practise on spare paper
before applying the
technique to your work.

Mixed media work (*right*)
When the paintwork is dry,
very subtle changes in
color and texture can be
achieved by rubbing over the
surface with the side of a
pencil, chalk, or crayon.
This technique must be
applied near completion,
because you cannot
satisfactorily paint back over
the pencil work.

Brush rule work (*right*)
When adding very accurate
line work, you can use a fine
sharp brush and, with very
little paint, add brush lines
which are very straight. Hold
the ruler's edge up from the
surface, and run the brush's
metal collar along the rule.
Practise this technique
before applying it to your
painting.

Dry brush work (*right*)
Coarse textures can be
achieved if you apply thick
paint with an old brush.
Because the paint is dabbed
onto the surface, or dragged
onto it, do not use new or
good quality brushes. Take
care not to apply too much
paint as this can peel off if
handled roughly or can
build up, creating artificial
shadows which appear
when your painting is
photographed for
reproduction.

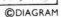

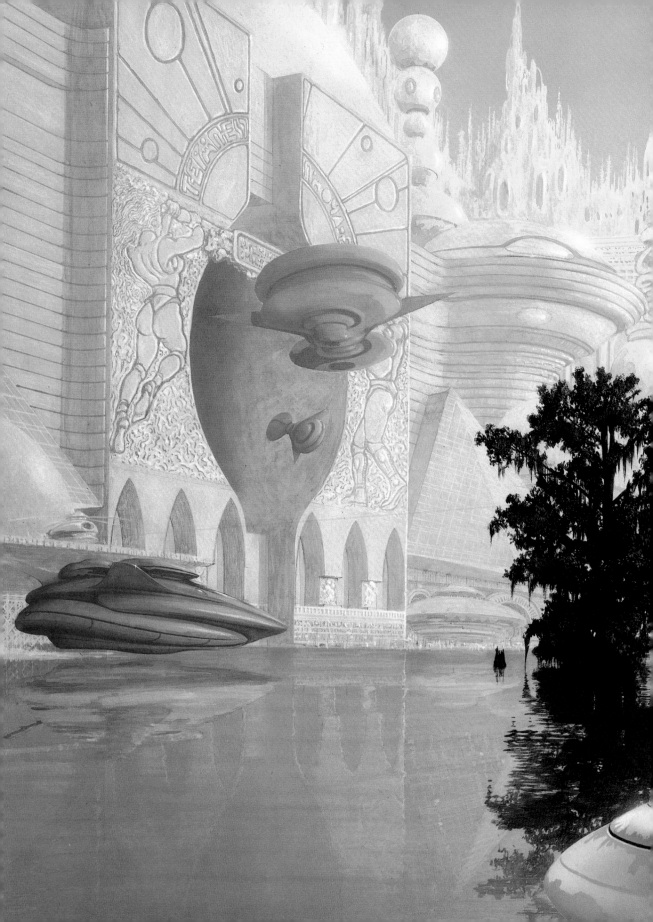

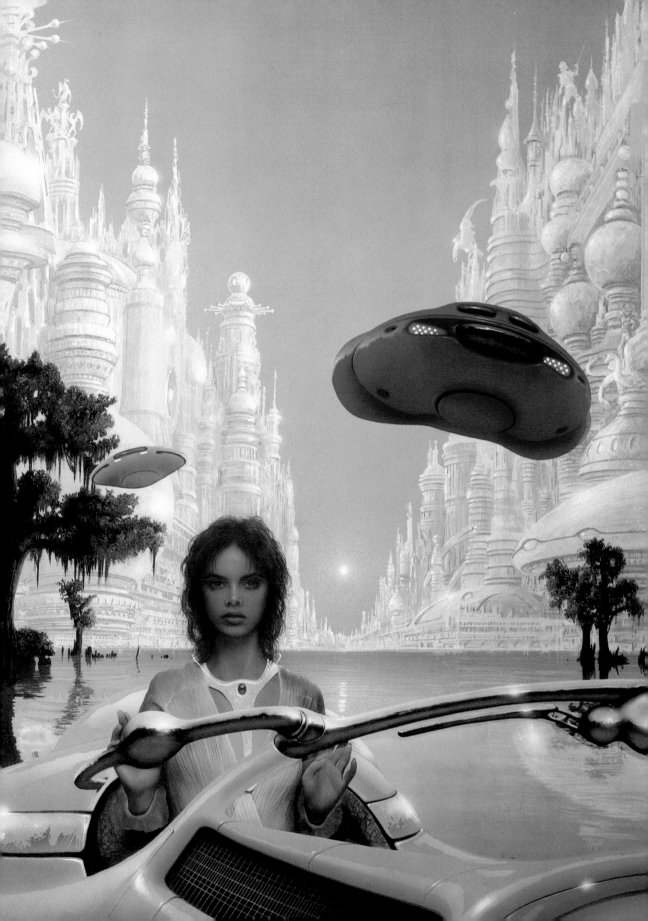

Acrylic colors

Jim Burns
Book jacket design for *Majipoor Chronicles*,
published by Victor Gollancz Ltd, UK
27½" x 19¼" (70cm x 49cm)

Jim Burns is a renowned artist who works for publishers and movie directors in the science fiction genre. He lectures at conferences on the role of the visual artist in creating new images to match the advancing ideas. His images are impressive because they have a high quality of reality, and depict a futuristic world of vehicles, people, buildings, monsters and landscapes. Using acrylic paints applied with both brush and airbrush, almost all of his inspiration springs from his ability to see opportunities for creating futuristic worlds from contemporary sources such as glossy magazines.

Book jacket design

Jim has produced many covers for science fiction books and he always insists on being allowed time to read the book and interpret its subject. Authors who have seen his work specifically ask for his imaginative interpretations. The cover (*left*) is for a collection of stories about the fantastical world of Majipoor. Jim has caught brilliantly the isolation felt by the girl as she enters the alien city. The composition is particularly striking in that it draws the reader into the subject by the acute perspective and the dominant foreground elements. Notice how carefully Jim has subdued the colors behind the text so that the typography does not conflict with the tonal values of the image.

Painting technique
The painting of the *Majipoor Chronicles* cover was produced on fiberboard which had been primed with acrylic gesso to produce a strong, smooth base. The large, even areas of color are airbrushed layers of thin acrylic paint. The luminous colors are produced by combining layers of acrylic paint with glazes.

Sources
Jim has an enormous collection of photographs cut out from glossy magazines. He finds that Italian fashion magazines and sports-car magazines are a good source for sophisticated images. The reflective polished surfaces which characterize his work echo the polished style of modern magazine photography.

Other applications
Jim has been asked to apply his creative ideas to the world of movies and even to present-day vehicle design. He worked in Hollywood on the movie Bladerunner where his enthusiasm for futuristic vehicles was incorporated in the movie sets. The sketch (*below*) shows one of his many ideas for vehicles in the movie. In Europe he has also produced ideas for new electrically-powered vehicle design in which traditional body shapes have been completely rethought.

©DIAGRAM

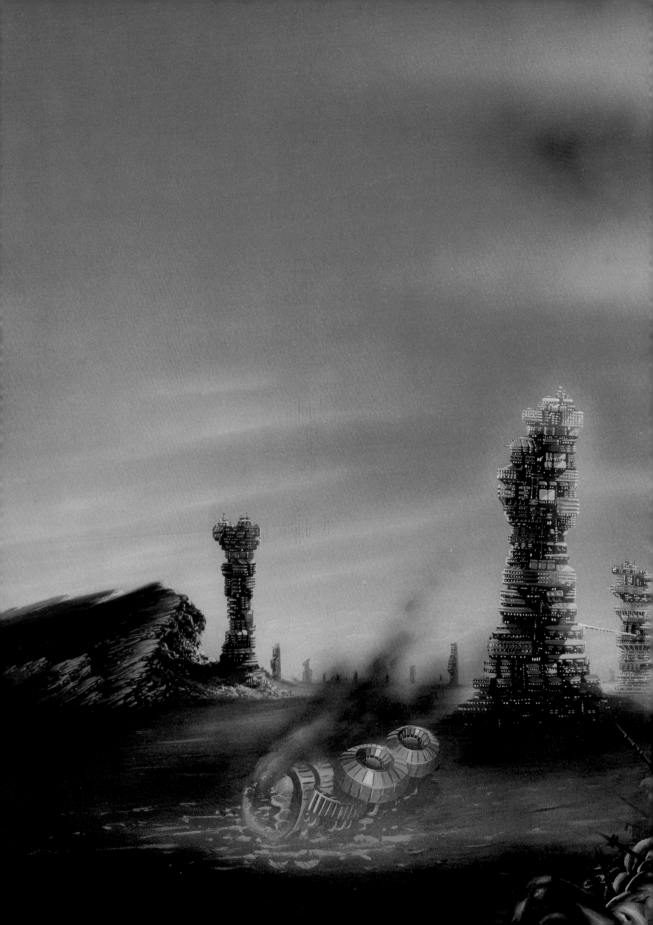

Acrylic and oil colors

Alan Craddock
Book jacket design for
Planet of the Damned,
published by Futura, UK
21½" x 27½" (55cm x 70cm)

Alan Craddock is one of a new generation of artists who have developed their skills to suit the needs of publishers of science fiction and the rising popularity of a 'comic culture.' From childhood he collected small-format comics and advertisements for bodybuilding aids. He is a self-trained artist, but was inspired and given confidence by his high school art teacher. All his technical skills have been developed by a process of experimentation and his efforts at mastering his craft. His images are simple in composition, forceful, direct and memorable.

Folk heroes (*right*)
Alan's enormous knowledge of popular American comic culture means that he can use hero figures as a basis for his ideas. Flash Gordon, Buck Rogers, Superman, Spiderman, The Incredible Hulk, Doctor Death, The Spook, Conan the Barbarian, Deathlock and a gallery of other square-jawed, bodybuilding giants strut through his pictures. They remind the science fiction readers of their own comic strip heroes.

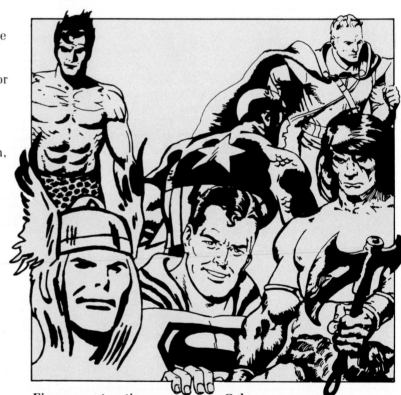

Figure construction
Alan frequently starts with a figure from a comic. In the painting (*opposite*) he copied the pose of his hero, The Spook (*left*). This negro zombie has a muscular physique and a dark, shiny skin texture. Alan added futuristic weaponry and a lifeless female form.

Color
Alan developed his own color system using oils and acrylic paints to produce radiant lighting and luminous images. He sprayed a glaze over each section of the work, building up thin layers of translucent color over earlier brushwork or spray-work.

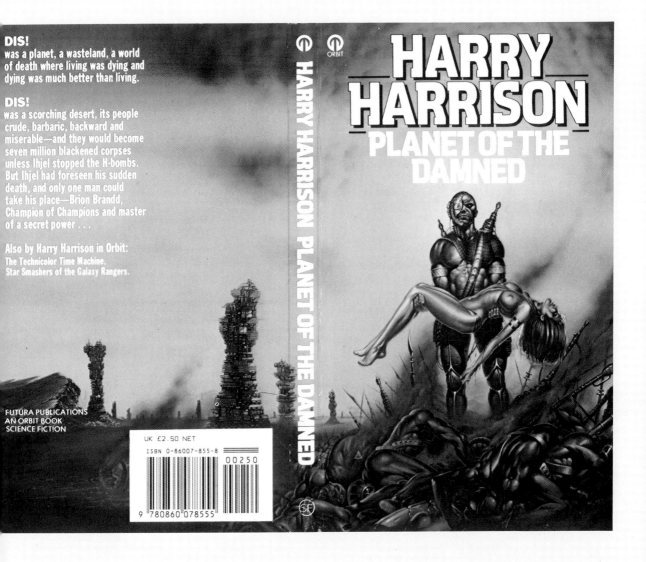

DIS!
was a planet, a wasteland, a world of death where living was dying and dying was much better than living.

DIS!
was a scorching desert, its people crude, barbaric, backward and miserable—and they would become seven million blackened corpses unless Ihjel stopped the H-bombs. But Ihjel had foreseen his sudden death, and only one man could take his place—Brion Brandd, Champion of Champions and master of a secret power . . .

Also by Harry Harrison in Orbit:
The Technicolor Time Machine,
Star Smashers of the Galaxy Rangers.

FUTURA PUBLICATIONS
AN ORBIT BOOK
SCIENCE FICTION

UK £2.50 NET
ISBN 0-86007-855-8
00250

9 780860 078555

ORBIT

HARRY HARRISON PLANET OF THE DAMNED

HARRY HARRISON
PLANET OF THE DAMNED

Composition (*above*)
The painting was composed in order to enable the publisher to print the title and other details on the cover. Artists are often required to produce work in such a way that the elements of the picture are positioned to suit the requirements of the publisher.

The medium
Alan worked on strong smooth artist's board and built up all the detail in pencil directly onto the surface of the board. He then sprayed on (without using masks) thin layers of acrylic paints. He completed the painting using artist's oil colors applied thinly. One of his most successful techniques is to gently remove the surface of the painting using a hard pencil eraser. Carefully handled, this technique creates highlights and reveals colors applied previously.

© DIAGRAM

125

Oil colors

George Sharp
Illustration from *The High Kings*,
published by Ballantine, USA
23½" x 17¾" (60cm x 45cm)

George Sharp's technique is to combine very detailed photographic references with his highly accomplished skills in figure and animal drawing. He normally works in oils, initially applied in thin layers, which build up the detail to produce an effect of glowing inner light. The surface is a very finely textured canvas, which George stretches and primes himself to produce a very smoothly surfaced finish and a card-like absorbency.

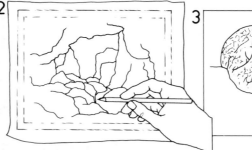

Choosing the composition

The idea for the scene was an image which developed in his mind. The story seemed to spark off the picture of a dark sea cave, occupied by a basking, fat, contented dragon.

1 The first stage was to obtain photographs of caves, and George was lucky to have a friend who took photographs of the spectacular volcanic sea caves on the Canary Islands.

2 To select a suitable view, George first transferred the floor planes of the cave onto tracing paper.

3 He then composed, in great detail, a pencil study of a fat dragon. Great care was taken at this stage to resolve the construction and features of the invented dragon, as working out details on the canvas destroys the purity of the final work. Remember, a problem left until the painting stage is a problem with increased dangers of spoiling the cleanliness of the final result.

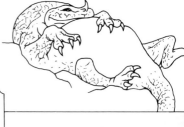

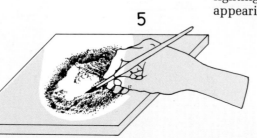

Establishing the images

4 George uses a photographic projector to transfer his studies onto canvas (*left*). This method enables him to paint the tonal areas directly onto the surface without the presence of outlines and construction marks. You can use a home transparency projector and transfer your pictures onto the wall against which you have placed your work surface.

5 George begins with the dark areas of the cave to establish the composition. He then projects his drawing of the dragon into the central area. Using this method enables you to combine any number of elements very accurately, but care must be taken to imagine a common source of lighting to avoid the images appearing out of context.

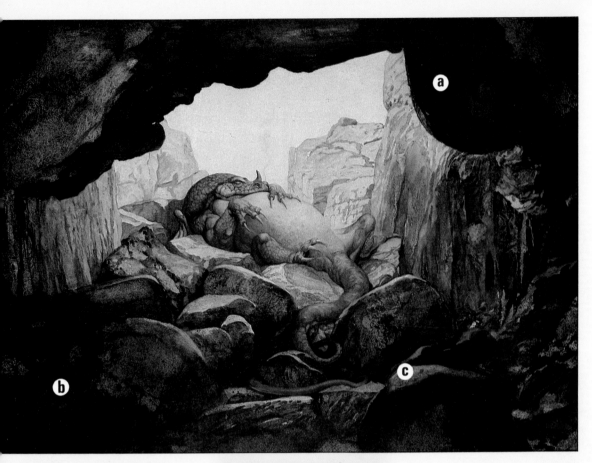

Building up the detail

The dark areas were slowly built up to form the major structures of the composition (**a**), and, within these structures, textures were established by dabbing the wet surface with pieces of kitchen roll (**b**) (detail *right*, actual size). This technique is excellent for natural surfaces, but requires great care as you are unable to repeat or revise the results if they are unsatisfactory. During the painting, the highlights (**c**) are worked back into the picture by using thicker, opaque colors.

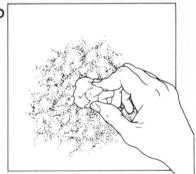

b

Constructing the dragon

Detail on the dragon was achieved with a very fine brush, and care was taken to smooth the dark drawing lines into each form. The anatomy is a mixture of crocodile (for the head), birds' claws (for the feet), amphibian (for the smooth underbelly) and the pose is one of lazy, relaxed enjoyment.

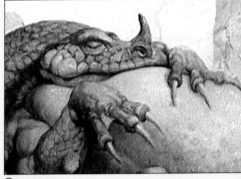

©DIAGRAM

129

Mastering techniques

The work of artists discussed in this section has shown that the techniques used have a great influence over the qualities of the work. You can only express yourself well if you are confident in your method. The pictures in this book are only reproductions and as such can do little to inform you of the surface quality of the works examined. Size and color are equally important and these are difficult to convey in a book. Without reading the text you might not have realised that the frozen breath on the figures in Giovanni's painting (page 110) was added with a sponge, that the rock surface in George's painting (page 126) was produced by removing the paint with a paper tissue, and that Nick's painting (page 98) is really a pencil and crayon drawing.

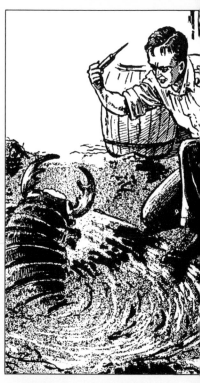

1 Pen and ink
This detail shows the scratchy quality of a pen used with confidence and speed. The original was obviously drawn much smaller. This technique is seldom used now by illustrators.

2 Brush and ink
Brushes create lines of varying thicknesses with ease. They are commonly used among comic book illustrators who will often plan in soft pencil and go over the plan with ink and a finely-pointed brush.

3 Chalks, brush and ink
In this example chalks have been highlighted with a touch of white paint. This is now rarely used.

6 Flat area work
This is a copy of a Mexican stamp design. This type of drawing is produced using a fine pencil to plan the design, then the large areas are filled-in using a paintbrush.

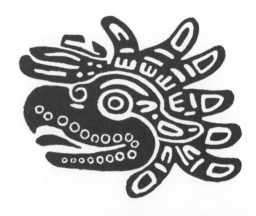

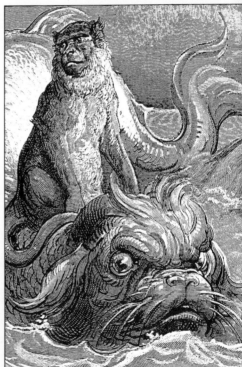

©DIAGRAM

4 Technical pen and brush
This is an actual size copy of a movie still. The large dark areas are produced using ink and brush. The gradations are added in the form of dots made with a technical pen.

5 Splatter technique
Here the dramatic effect is achieved using a tooth brush to spray the ink on (see page 136). Practise this method beforehand and use it with caution.

7 Reproduction methods
This example is a wood engraving, a copy of a study by the 19th century artist Gustave Doré. The engravers employed great skill to reproduce the textural and tonal qualities of the original watercolor.

Dry medium techniques

Pencils, chalks and crayons are tools of convenience. Pencils are ideal for thinking out your ideas and planning as the lines can be covered over easily with paint. Chalks and crayons are very useful for building up tones. Pencils are available in a wide range of lead strengths – the hardest produce the finest and lightest marks, the softest the darkest and roughest marks. They can therefore be used to record a very wide range of tonal values which can represent the qualities of later, more resolved work. Dry medium tools need a suitable texture for their use – such as cartridge paper – but even so, finished work must be sprayed with fixative solution to prevent smudging. Unfortunately, one drawback of this medium is that the subtle qualities of the lines and tones produced make reproduction of the image difficult.

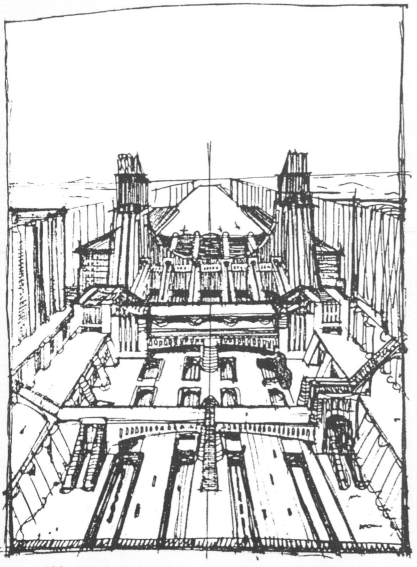

Thinking it out
The pencil drawing (*left*) is one of many produced by the architect Sant 'Elia who used a pencil to sketch his ideas of futuristic cities. Pencils are ideal for quickly working out your ideas, revealing your first thoughts, and reworking the original image.

Tonal studies
The two pencil studies (*above right* and *right*) are by Lee aged 18 years. Both drawings, which he intends to use as reference material, show the ability of the artist to use the pencil to obtain a wide range of tones from the soft lead of a single pencil.

Planning
Having worked out your ideas you can use pencils to construct the composition and also produce independent studies of individual sections of the design. The illustration (*right*) is a preliminary sketch for a science fiction composition.

Wet medium techniques

Fantasy artists usually use wet medium tools to produce drawings intended for reproduction as they make clear, strong marks. Since these marks are difficult to erase the artist normally preplans his design in light pencil or chalk. Working with a wet medium requires you to use stronger papers than with pencils or chalks, as the moisture can cause the surface to buckle. There are two types of tool, those containing their own ink; technical pens, ball point pens, felt tip pens, and those you dip into ink such as brushes and dip-in pens.

Dip-in pens
These are very useful to give a drawing energy and life as a good strong pen nib produces lines which reveal the pressure and speed of the hand. The drawing (*right*) by Heinrich Kley beautifully captures the imaginary black-feathered crow man.

Technical pens
Architects, engineers and designers use pens which produce a regular thickness of line. These are best used on plastic sheets or hard, smooth card as the fine point can easily snag on the surface of rough papers. Each pen produces a constant line thickness so a variety of pens must be used to achieve a drawing with varying thickness lines like the example (*right*). This drawing uses rules and templates to guide the pen during drawing.

134

Brushes

Drawing with a brush offers the opportunity of producing lines which can thicken and narrow depending on the pressure of the hand or the amount of ink on the brush. Brushes are able to produce efficiently both fine lines, such as the whiskers on the drawing (*right*) or large solid areas such as the victim's garment.

Felt tipped pens

There are many varieties of felt tipped pen, varying in thickness and color. These normally use kerosene as an ink base so marks cannot easily be refined. They are also very easily used up as the contents dry out after some use and the pen must be discarded. The drawing (*right*) uses fine pens for the detail and broad pens for the larger areas.

Ball-point pens

These are very rarely used for final designs but very useful as a means of quickly jotting down ideas. The doodles (*below*) by Mike, aged 14, show how quick and easy drawing with a ball-point pen can be.

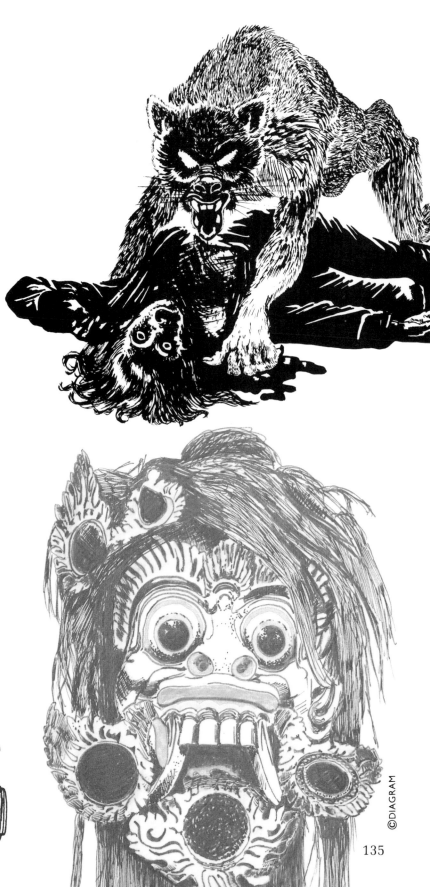

©DIAGRAM

135

Airbrush

Using an airbrush requires a different type of skill from that used with brushes or pencils. The paint is finely sprayed onto the surface and can achieve either very smooth even areas or fine gradations – both of which are difficult to achieve with other tools. The technique has been greatly exploited by artists depicting science fiction subjects. It is often difficult to detect the working methods of good airbrush artists. They usually work from simple dark areas to intricate light ones. Graduating between such areas is a very skilled job. While working the artists protect sections of the painting with paper masks so that only the areas they are directly working on are exposed. In the hands of masters very fine detail is achieved, often reinforced with careful brushwork.

Toothbrush technique
Coarse gradations and textures similar to spray work can be achieved using an old toothbrush and a small stick rubbed across the inked bristles. Before applying paint or ink, mask areas you don't want it applied to.

Progressing a painting
Robert Chapman began the painting (far right) by producing a careful pencil sketch of the idea. He worked with a hard pencil on tracing paper using templates to construct accurately the ovals of the major parts of the design.
1 He then transferred-down onto finely-grained cartridge board the major elements of the design, subsequently covering the board with a film of clear masking material.
2 He then removed the outer areas having first cut a very careful line around the central object using an extremely sharp scalpel. This aspect of working with an airbrush requires a great deal of skill to avoid cutting too deeply into the surface of the board.
3 The dark background areas were sprayed.
4 Next, he removed the central mask and cut a new mask to protect the background areas while working on the central design.
5 Bob cut a series of masks within the central area to enable him to spray different

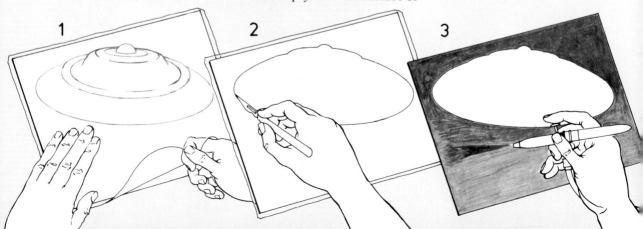

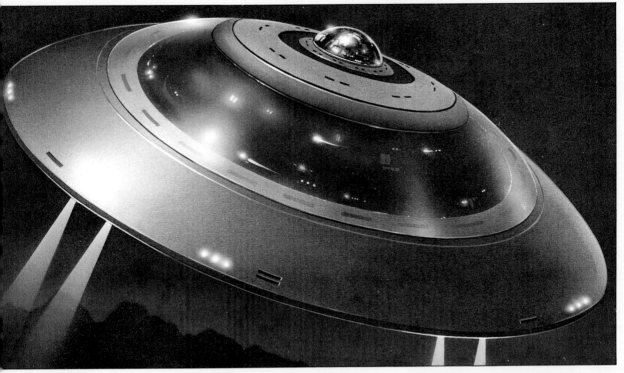

areas with a variety of
gradations of color.

6 When all the surface of the
board had been painted, Bob
began 'drawing-in' the detail
with a fine brush. He made
sure that there were no white
areas left where the edges of
the masks had been. He
finished off by applying
carefully placed, small areas
of bright spraywork.

Science fiction worlds

This is an airbrushed
painting by Robert Chapman
(see page 124).

The artist must hold clearly
in mind the tonal values of
the areas obscured under the
mask to avoid producing
results which flatten the

image. Using the airbrush
requires a steady hand and
smooth movement. One of
the most impressive
qualities of airbrush artists is
their ability to add very
small gradated values such
as shining lights or softly
darkened forms.

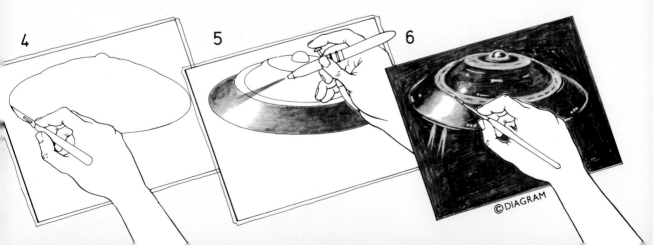

©DIAGRAM

Adding textures and tones

There are two ways of adding tone or texture to a drawing. If the drawing is to be reproduced, you can either instruct the printer to add mechanical tone or add the tone yourself and experiment with tonal values. You can do this using self-adhesive or rub-down sheets of mechanically produced tone. Store sheets carefully, keeping them flat and free from dust.

Selecting a texture
A large range of tones and textures, both regular and irregular, are available, but they tend to be costly. Only buy the ones which you know you want to use, and store unused pieces carefully. A few examples of the available range are shown (*below*).
A Rub-down
B Self-adhesive film

Applying rub-down tone
(*below*)
1 Complete a line drawing.
2 Lay the sheet of tone over your drawing and rub down using a blunt tool (a burnisher is ideal). Lift the sheet up occasionally to check the effect.
3 Move the unused tone to another area and apply again. You can build up the texture by laying one pattern over another.

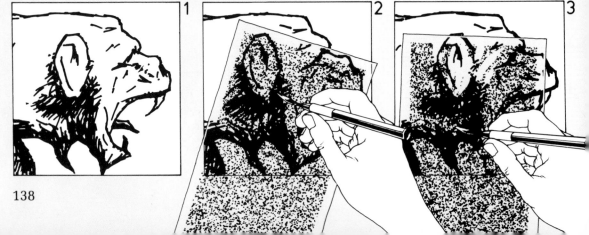

Applying self-adhesive film (*below*)
Using this method you will have strong, black containing lines with a variety of textures. Avoid using tones of either type over large areas.
1 Complete your line drawing.
2 Lay part of the texture sheet (with the backing sheet still attached) over your work. Using a scalpel, cut out roughly, but not wastefully, the area required. Remove the backing sheet and the unused pieces of tone with care. Put the shaped area of tone over your work and rub down in the centre only to keep the piece in place.
3 Carefully cut around the area you want tone on.
4 Lay a piece of spare paper on the area and burnish all over using a smooth blunt tool.
5 Make sure there is no dirt on the drawing before adding any further tones.
6 Repeat this process adding other tones.

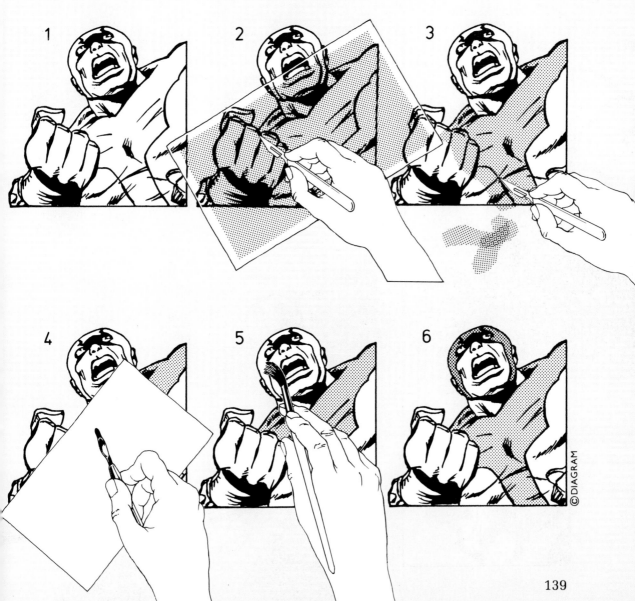

Combining media

Drawings can accommodate a wide variety of unusual textures. Explore the possibilities. Often the use of several techniques leads to exciting discoveries which can be used in later drawings. Textures should not be employed for their own sake – they should be an integral part of the drawing. Try not to use methods which damage the surface of the picture. All the examples on these pages are of primitive, coarse textures which, when applied correctly, can give your drawings life and vitality.

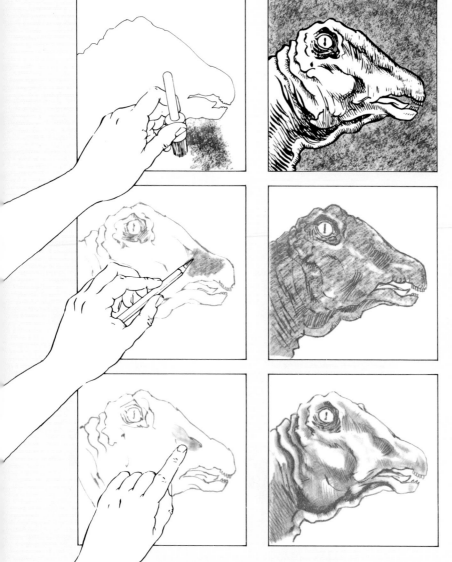

Stipple
Regular textures can be made using a large, blunt-ended brush and stippling the tones (*left*). Protect the other areas with a mask, and do not use thin ink or paint, as this can cause blotches. Always test the effect of a freshly loaded brush on a piece of scrap paper before applying.

Frottage
A pattern can be added by placing your drawing over a coarse-grained surface (such as a piece of wood) and rubbing over the drawing with a soft pencil (*left*). Make sure the drawing does not move during the process. Only pastel, crayon and pencil are suitable tools for this method.

Smudging
A very common technique, but take care to avoid a messy result. The end of your finger (*left*), soft material, or a putty rubber can be used to spread the tone. Spray fixative over the finished drawing to prevent accidental smudging.

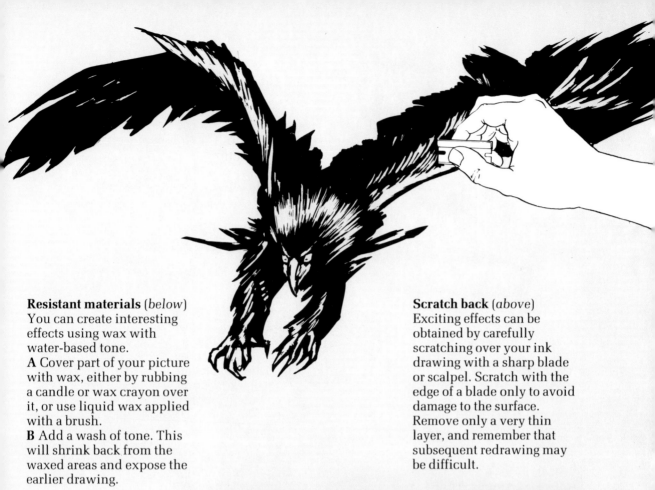

Resistant materials (*below*)
You can create interesting
effects using wax with
water-based tone.
A Cover part of your picture
with wax, either by rubbing
a candle or wax crayon over
it, or use liquid wax applied
with a brush.
B Add a wash of tone. This
will shrink back from the
waxed areas and expose the
earlier drawing.

Scratch back (*above*)
Exciting effects can be
obtained by carefully
scratching over your ink
drawing with a sharp blade
or scalpel. Scratch with the
edge of a blade only to avoid
damage to the surface.
Remove only a very thin
layer, and remember that
subsequent redrawing may
be difficult.

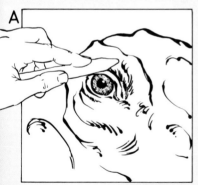

A

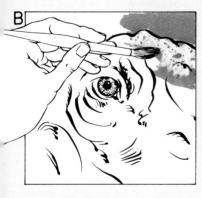

B

©DIAGRAM

Index

index